MW00561419

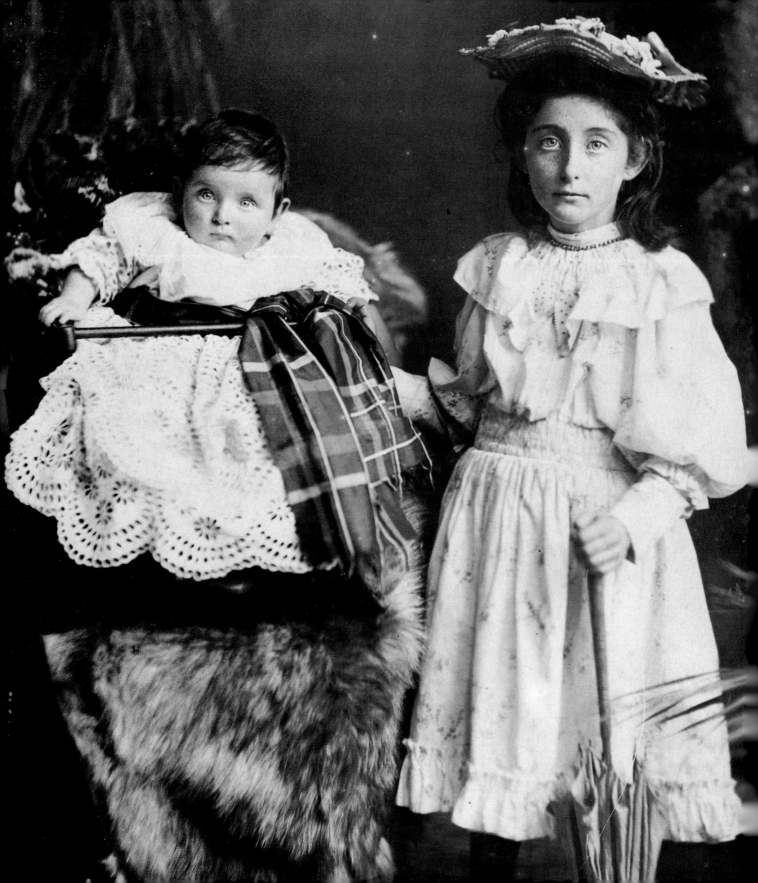

Children's Fashions of the Past in Photographs

An Album with 165 Prints
Edited by Alison Mager

Dover Publications, Inc.
New York

INTRODUCTION

With the advent of photography in the first half of the nineteenth century, portraiture, previously reserved for the few who could afford to commission paintings, became democratized. One of the most popular photographic categories until well into the present century was the formal studio portrait of children. Almost all proud and loving parents had such pictures made, and enough copies were ordered for distribution to a usually sizable circle of relations. This is why so many old photographs of children have been preserved.

Pictures of this type have not always been highly regarded by historians, with the exception of those taken in such famous studios as that of Joseph Albert in Munich (see No. 20) or Mora in New York City (see No. 90). Today, however, we are beginning to recognize the services rendered by the photographic profession as a whole in preserving the appearance and social attitudes of the passing day.

Without any pretensions to completeness or scholarly evaluations, the present volume nevertheless breaks new ground in presenting 165 typical studio photographs of children. One hundred thirty-seven photographers from fifteen states of the Union and from ten foreign countries are represented. The pictures range in time from about the 1860s to the early 1920s. The popular carte-de-visite and cabinet formats are prevalent.

These photographs are naturally crammed with information about children's clothing (formal or masquerade), playthings, baby buggies and other physical paraphernalia. But they also reveal nineteenth-century conceptions of the child as either a miniature adult or an animated doll. The emphasis on the proper sex-related poses and activities is also evident. Intentional humor crops up here and there. It is also interesting to observe the great variety of studio backdrops and decor in which the older traditions of portrait painting were faithfully maintained.

An unprejudiced eye will occasionally find that these lesser-known or anonymous photographers could achieve as much artistry as acclaimed Victorian masters such as Lewis Carroll. A list of the identifiable photographers and their cities has been provided.

It is hoped that the first brief effort this volume represents will serve as an incentive for fuller and more serious explorations of the artistic and social implications of this popular art form. Over the years, it has been the private collectors, more than the libraries and museums, who have preserved the photographic record of the past. The present book may give more people a vista of the wealth of charming and important material still available at low cost in antique shops and flea markets everywhere.

ACKNOWLEDGMENT

The publisher is grateful to the International Museum of Photography in Rochester, New York, for lending the following photographs included here: 12, 13, 14, 18, 21, 25, 39, 40, 45, 47, 53, 57, 61, 65, 69, 73, 77, 81, 85, 94, 111, 114, 122, 123, 128, 130, 132, 134, 136, 145, 151, 155. All the other photographs are from the collection of the editor.

Copyright © 1978 by Alison Mager.
All rights reserved under Pan American and International Copyright Conventions.

Publications, Inc., in 1978 under the title *Children of the Past in Photographic Portraits*.

International Standard Book Number: 0-486-23697-8
Library of Congress Catalog Card Number: 78-55864

Manufactured in the United States of America
Dover Publications, Inc.
31 East 2nd Street
Mineola, N.Y. 11501

Children's Fashions of the Past in Photographs: An Album with 165 Prints is a new work, first published by Dover

LIST OF PHOTOGRAPHERS

77. Gehrig, Chicago, Illinois
78. Frederick H. Pierson, Elizabeth, New Jersey
79. unidentified
80. Miss C. Smith, Lowell, Massachusetts
81. F. M. Bailey, Lima, New York
82. Edsall, New York City
83. Stout's Photographic Studio, Easton, Pennsylvania
84. Thomas J. Stofflet, Bangor, Pennsylvania
85. Bassett, Erie, Pennsylvania
86. Rockwood, New York City
87. Hill, Elizabeth, New Jersey
88. Pelham, Sing Sing, New York
89. Henry Merz, New York City
90. Mora, New York City
91. Herbert Salmon, Teddington (London), England
92. E. J. Ehrlich, Trebitsch (now Třebíč), Czechoslovakia
93. N. L. Christiansen, Kasson, Minnesota
94. Ehm, Brooklyn, New York
95. Jordan & Co., New York City
96. Dana, New York City
97. Brasier & Co., Brooklyn, New York
98. B. Marks, Mount Vernon, New York
99. Windsor Portrait Gallery, Brooklyn, New York
100. F. L. Huff, Newark, New Jersey
101. W. J. Lee, Rochester, New York
102. H. J. Thein, Newark, New Jersey
103. F. Ulrich, New York City
104. unidentified
105. J. W. Ward, Connellsville, Pennsylvania
106. De Youngs', New York City
107. Thomas, New York City
108. Fredricks' Knickerbocker Family Portrait Gallery, New York City
109. W. Kurtz, New York City
110. v. Werenbach, Vienna, Austria
111. Anson's, New York City
112. Z. Frey, Stryj (Galicia, Austro-Hungarian Empire; now Stryy, Ukraine, U.S.S.R.)
113. J. Mayle, Derby, England
114. Edsall Studio, New York City
115. A. J. Runions, Canton, New York
116. unidentified
117. J. H. Steiner, Jersey City, New Jersey
118. N. H. Reed, Pontiac, Illinois
119. unidentified
120. Langhorne, Plainfield, New Jersey
121. S. B. Hoffmeier, Easton, Pennsylvania
122. Anderson, Springfield, Illinois
123. Atelier Elite Palais Generali, Prague, Czechoslovakia
124. Brady, Orange, New Jersey
125. Rockwood, New York City
126. Lemont, Waltham, Massachusetts
127. Wright, Princeton, Indiana
128. Atchley, Rockford, Illinois
129. Joseph Huber, Vienna, Austria
130. H. Bishop, Chambersburg, Pennsylvania
131. unidentified
132. Carter, Worcester, Massachusetts
133. E. McGillivray, Ithaca, New York
134. Baker & Record, Saratoga Springs, New York
135. Ericsson, Brooklyn, New York
136. E. F. Hall & Co., Buffalo, New York
137. unidentified
138. Richter & Co., Philadelphia, Pennsylvania
139. Rudolf Zacharias, Regensburg, Germany
140. J. W. Crawford, Brooklyn, New York
141. Applegate, Philadelphia, Pennsylvania
142. Ludwig Schill, Newark, New Jersey
143. Lee, Phillipsburg, New Jersey
144. E. T. Wilson, Barton, Vermont
145. Halbach Bros., Sheboygan, Wisconsin
146. Scott, New Brunswick, New Jersey
147. F. Ulrich, New York City
148. Scott, New Brunswick, New Jersey
149. Rockwood, New York City
150. H. O. Klein, Lahr (Breisgau), Germany
151. Godfrey, Rochester, New York
152. Robbins Gallery, Bradford, Pennsylvania
153. F. E. Stanley, Lewiston, Maine
154. J. H. Smith, Newark, New Jersey
155. Victor Acker, New York City
156. Singhi, Binghamton, New York
157. Columbia Photo Co., Paterson, New Jersey
158. Otto E. Weber, Lancaster, Pennsylvania
159. Dunn, New Brunswick, New Jersey
160. Lee, Phillipsburg, New Jersey
161. Carl Zapletal, Vienna, Austria
162. unidentified
163. unidentified
164. unidentified

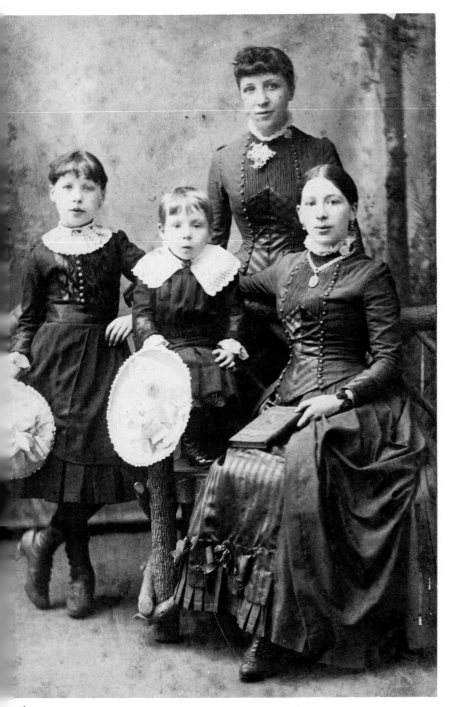

1

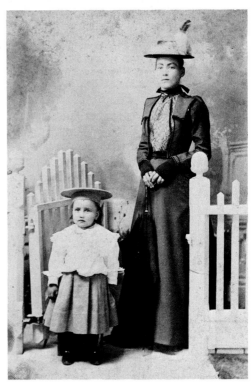

2

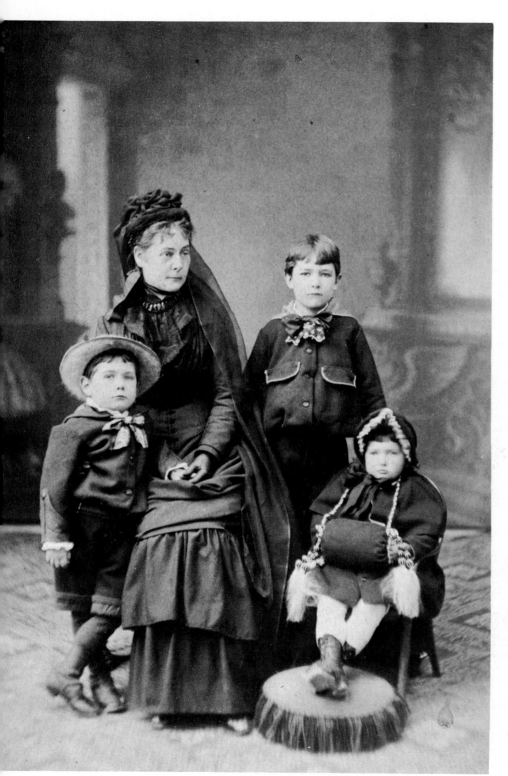

3

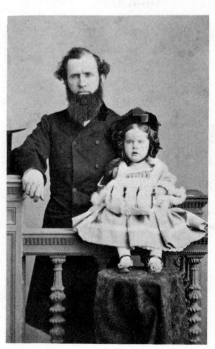

4

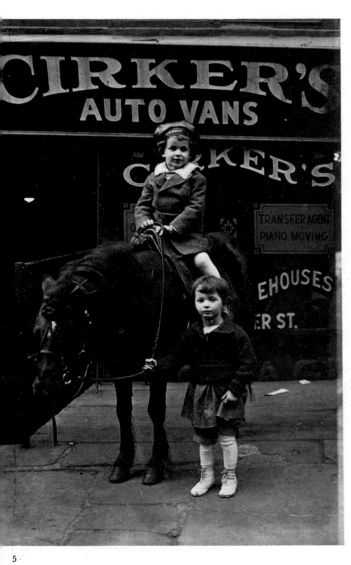

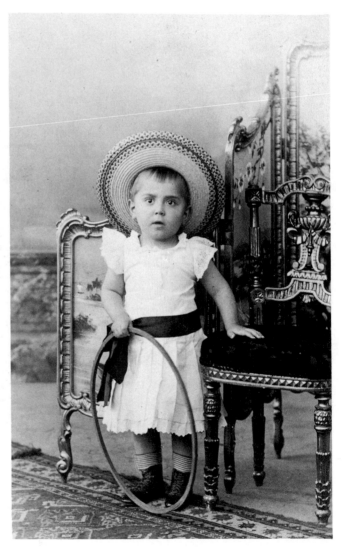

5

6

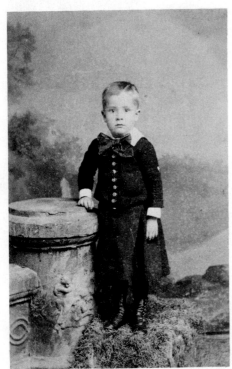

7

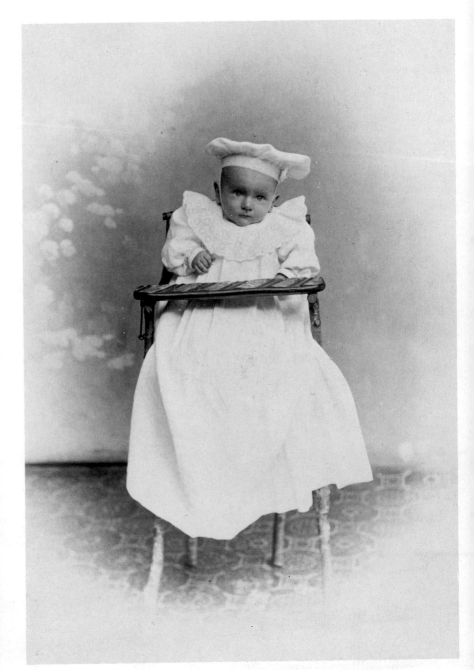

8

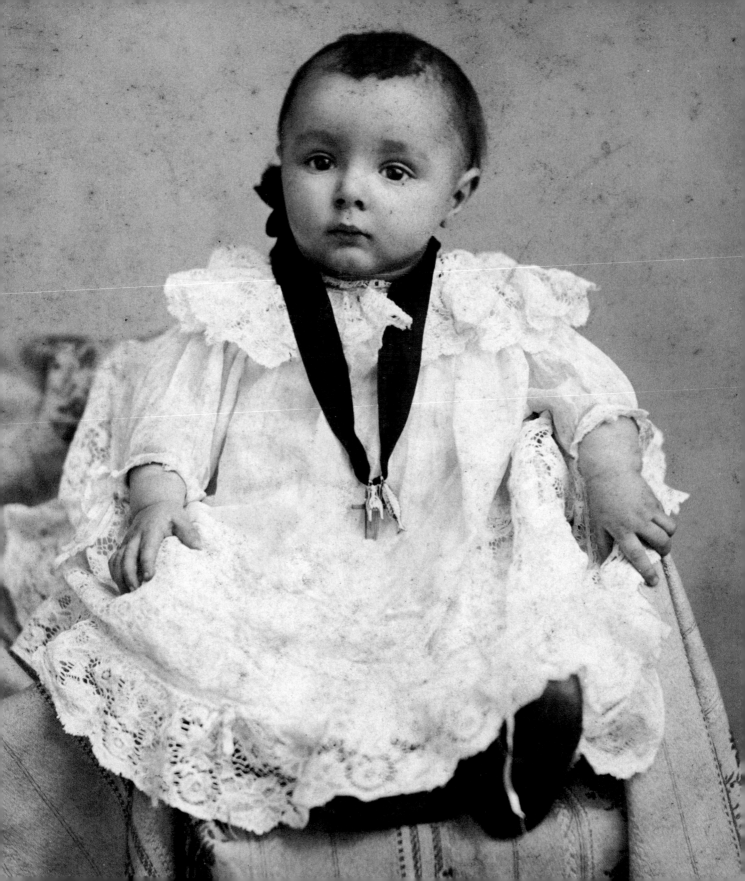

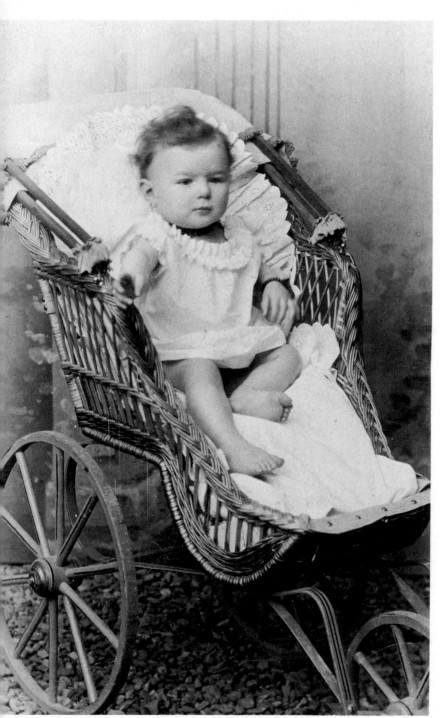

10

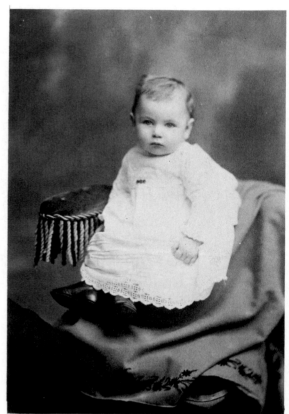

11

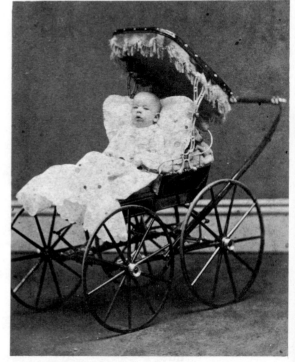

12

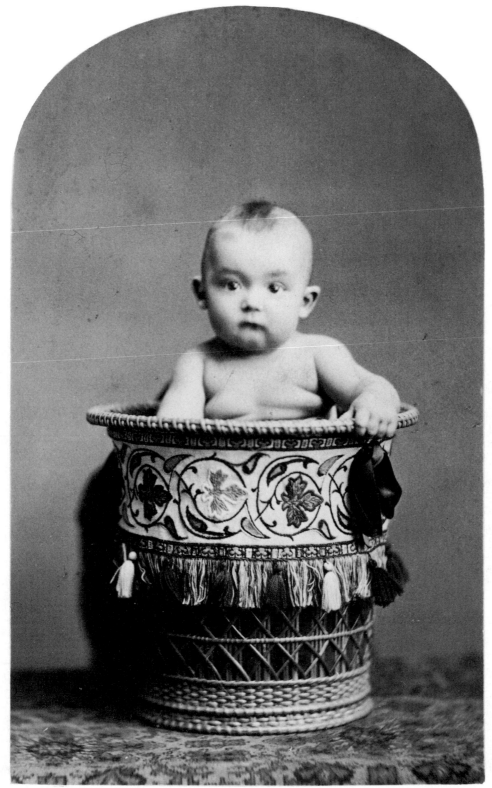

13

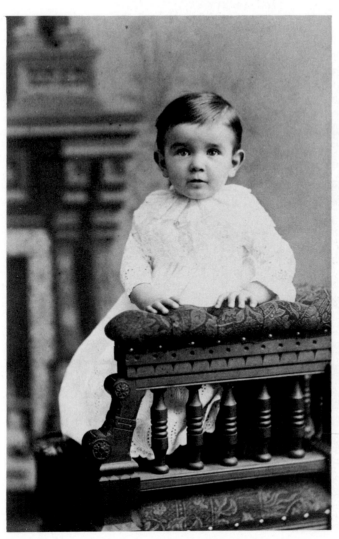

14

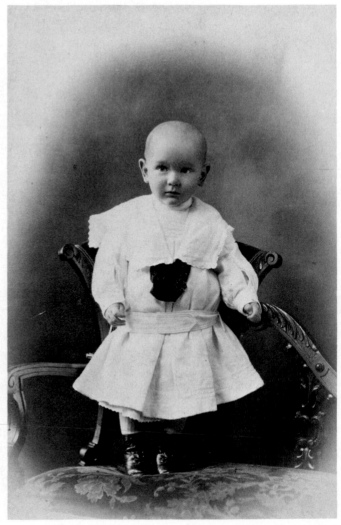

15

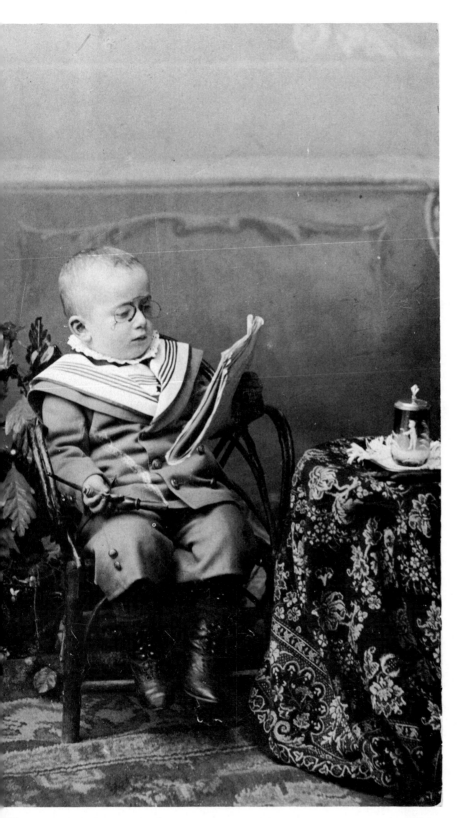

16

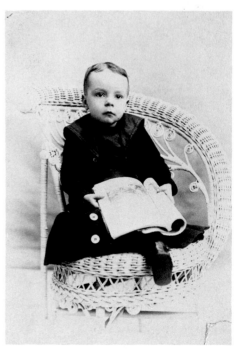

17

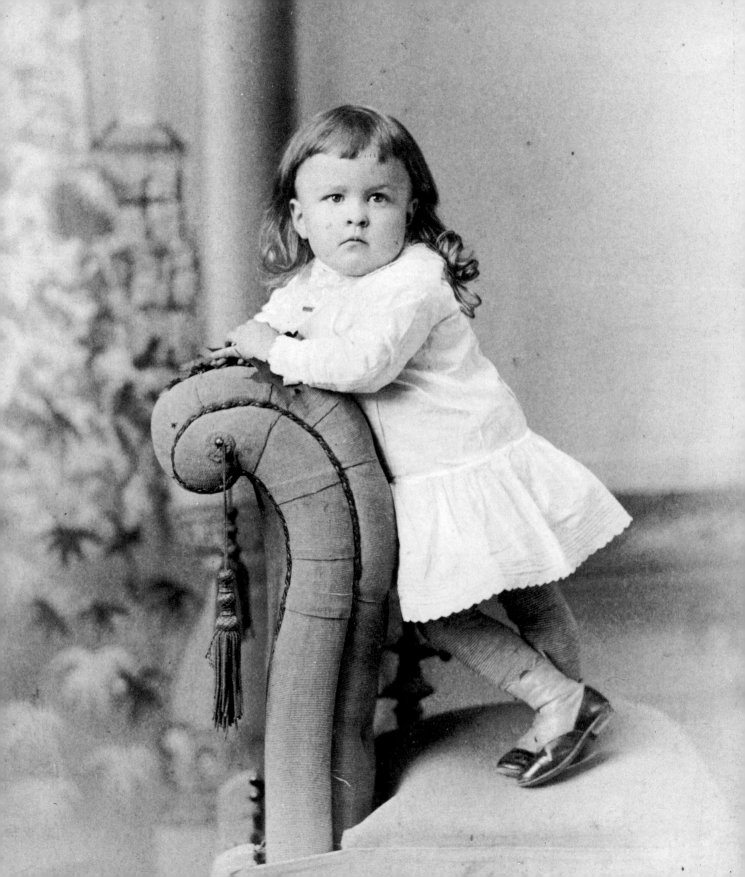

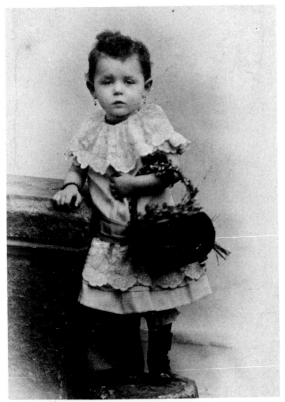

19

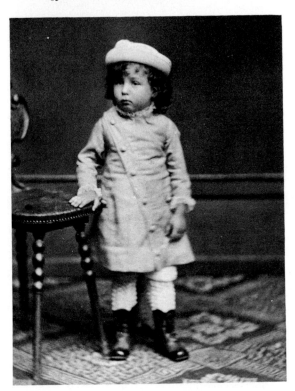

20

21

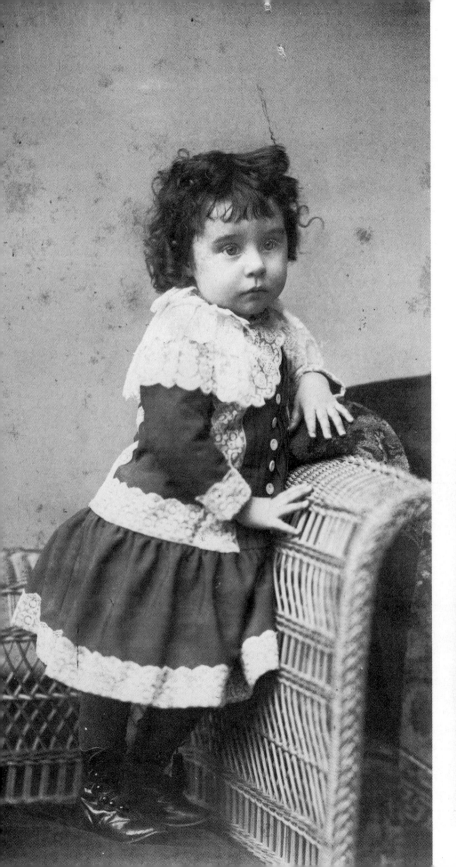

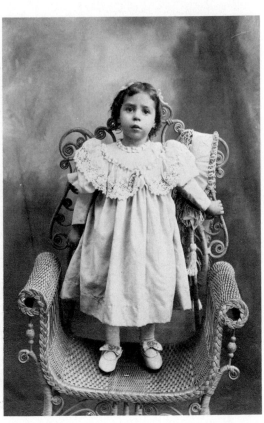

23

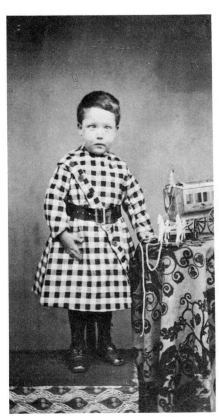

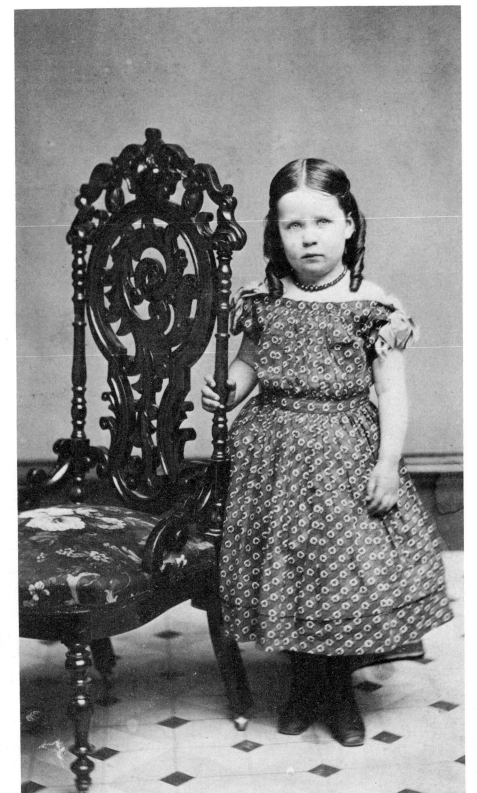

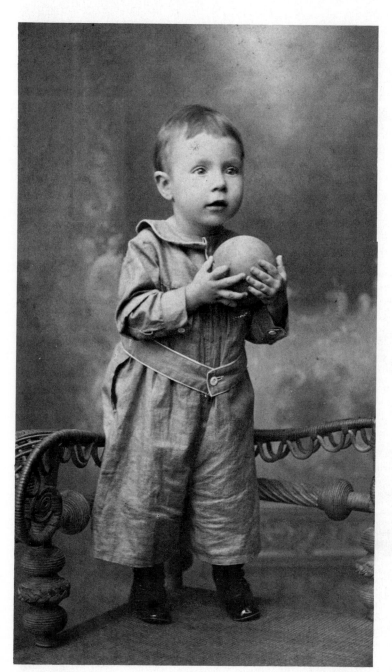

26

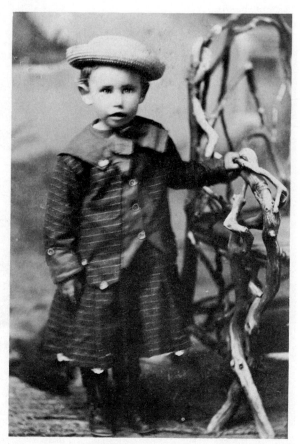

27

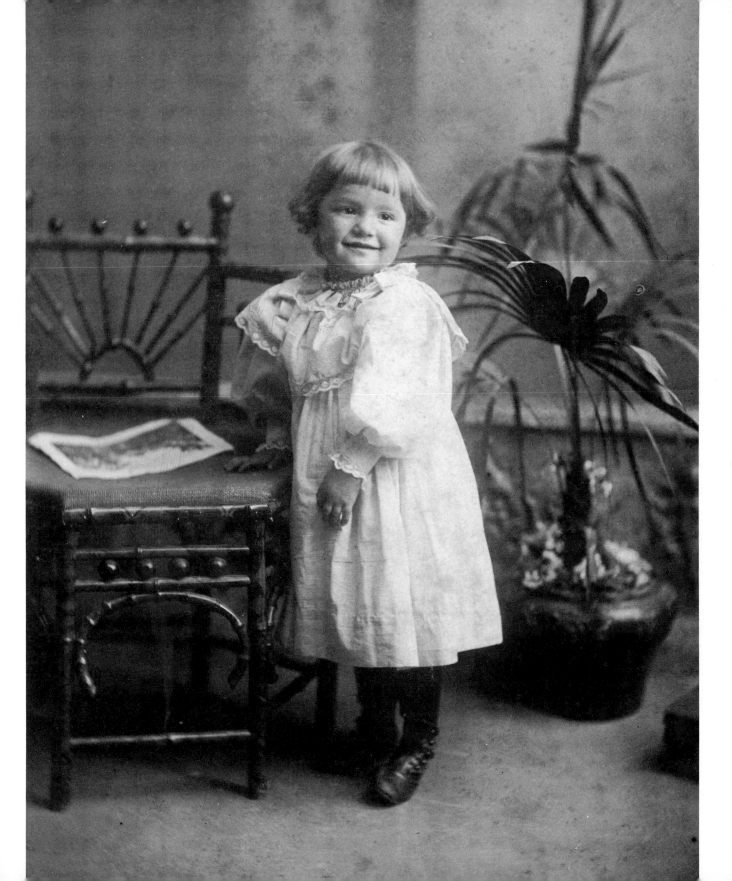

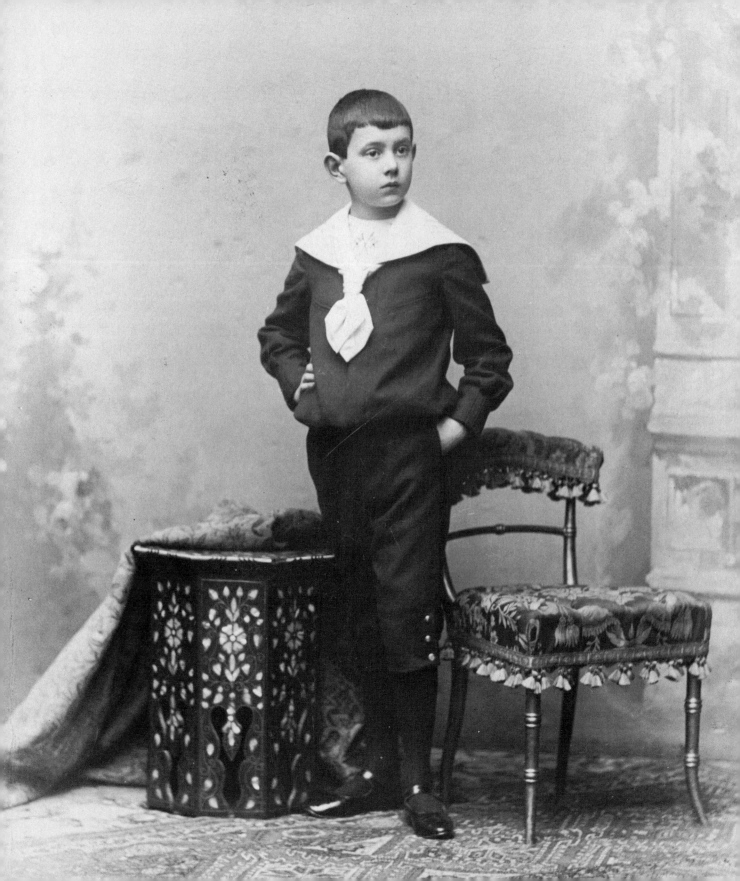

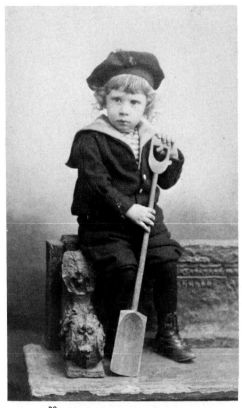

30

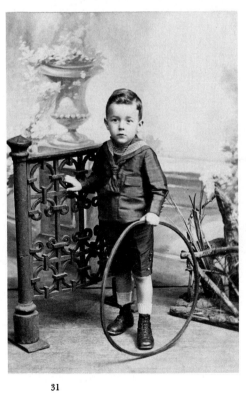

31

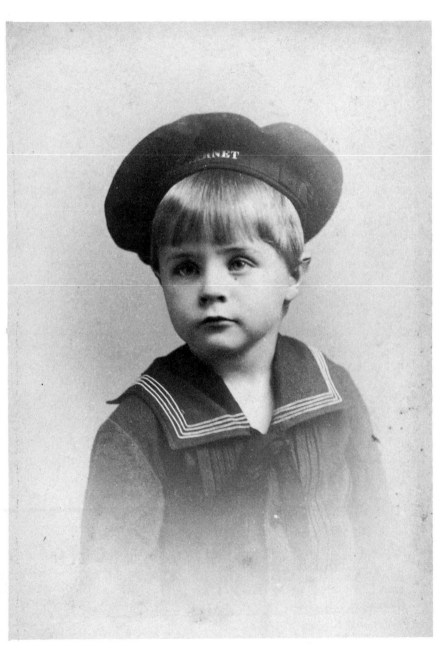

32

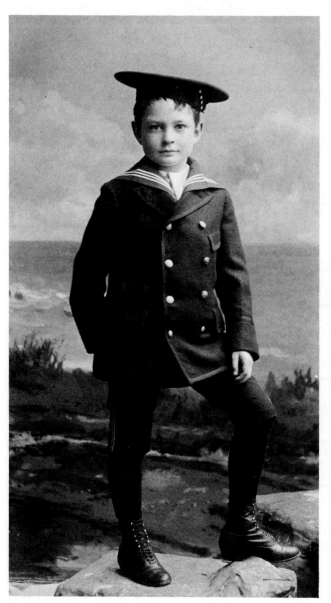

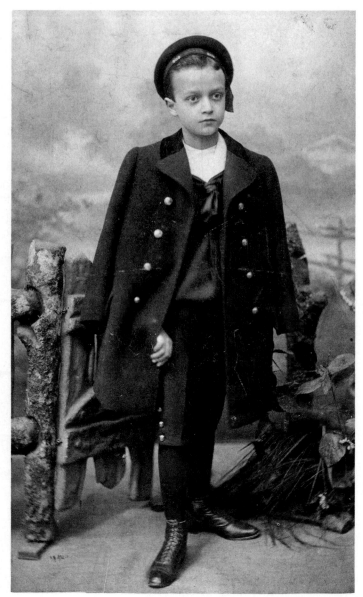

33 34

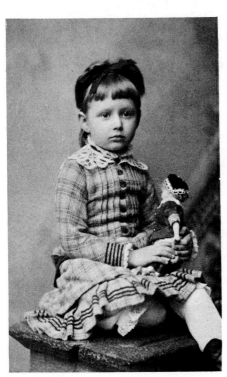

35

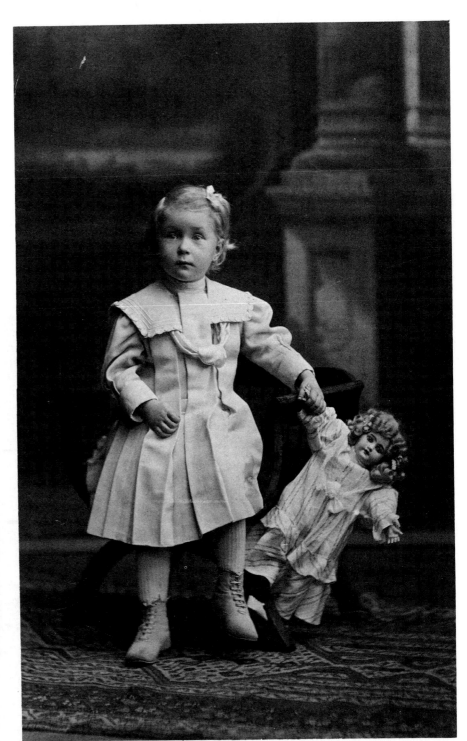

36

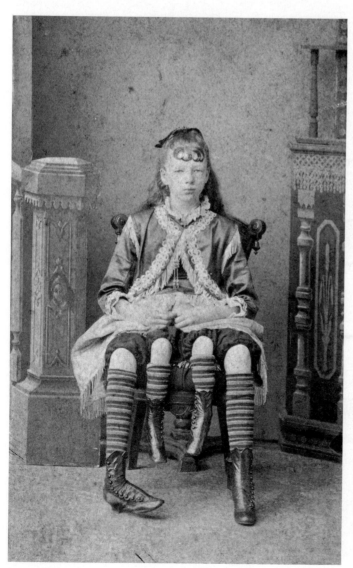

37

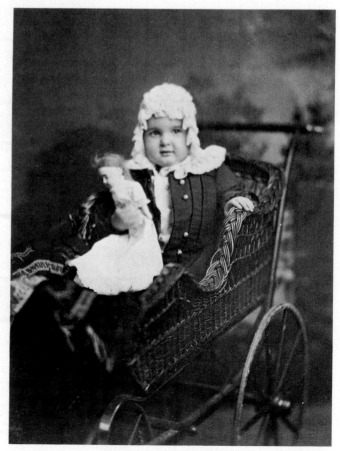

38

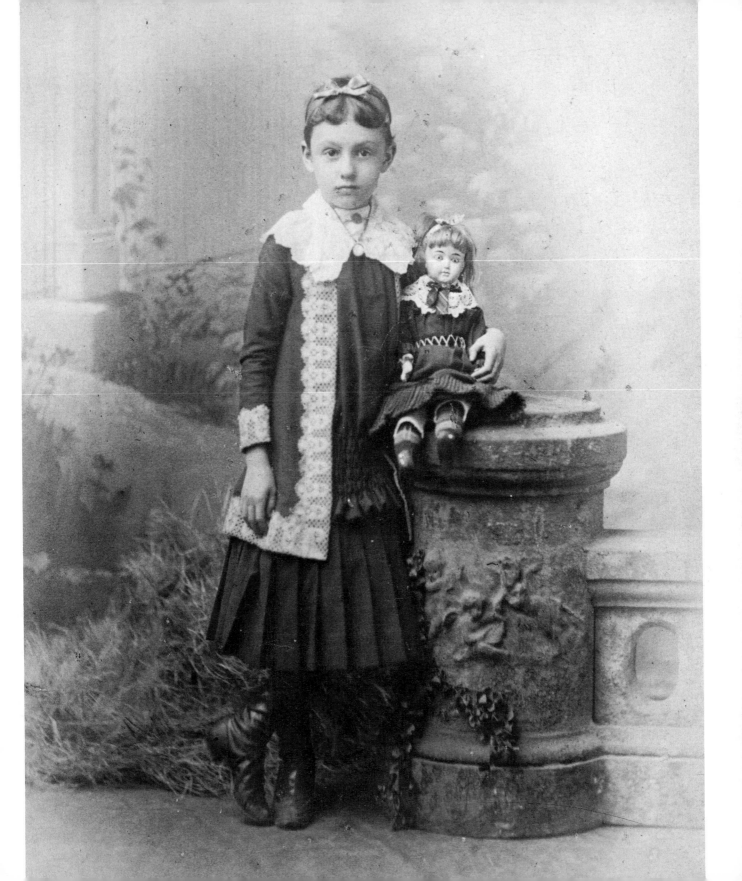

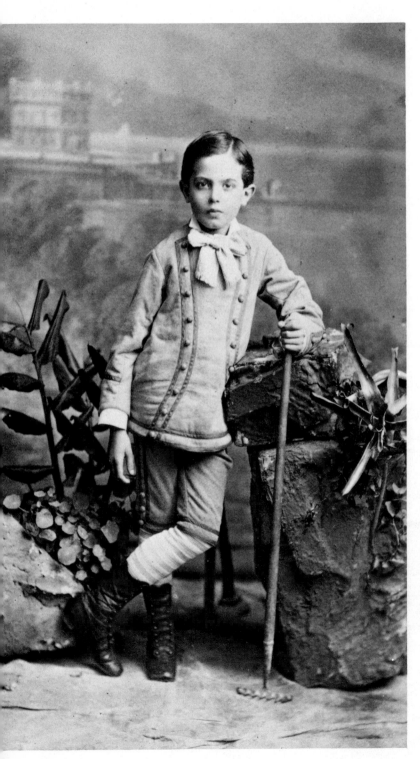

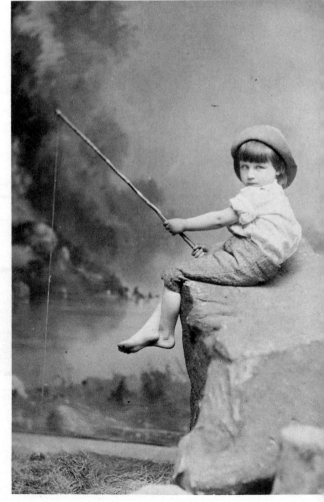

40

41

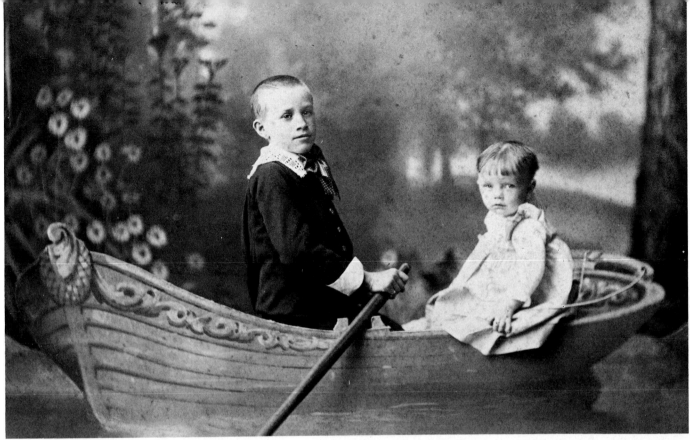

42

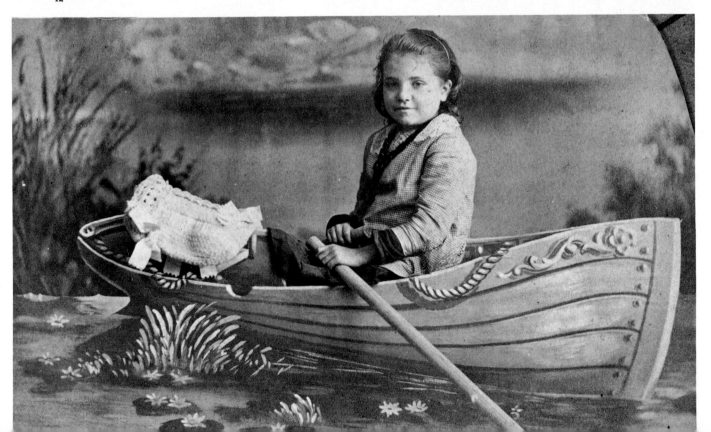

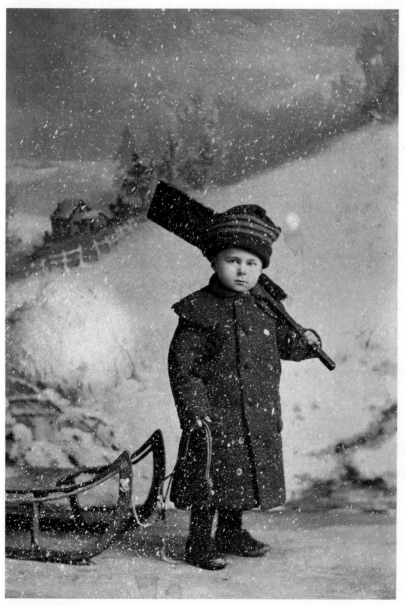

44

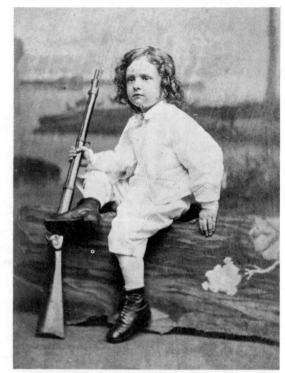

45

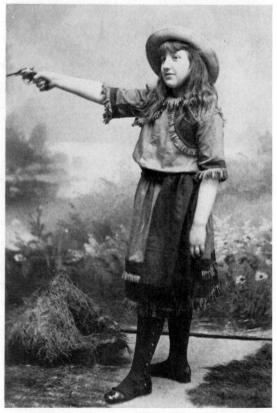

46

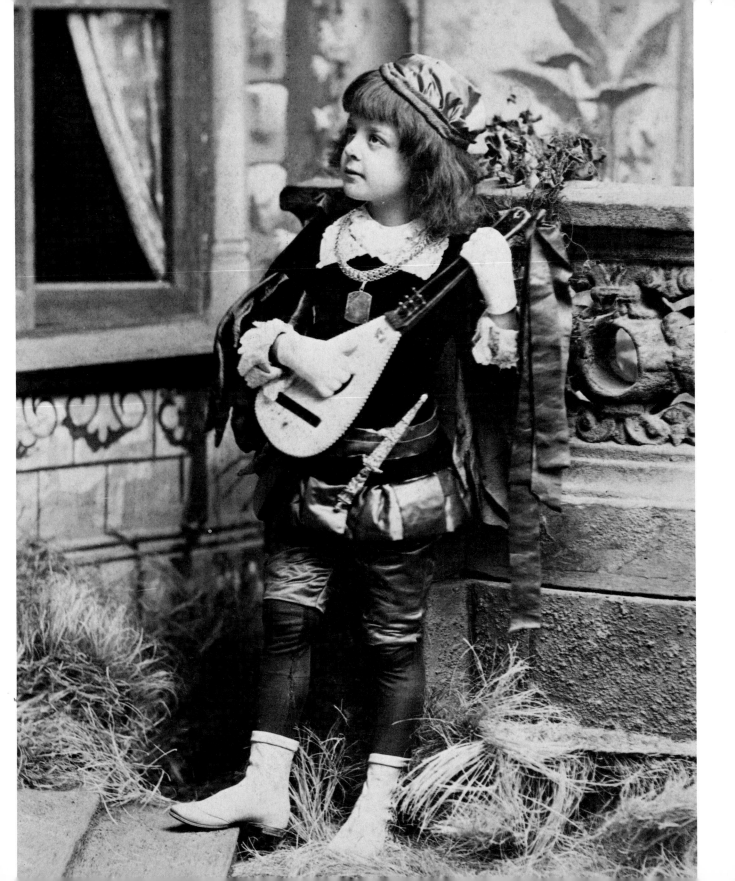

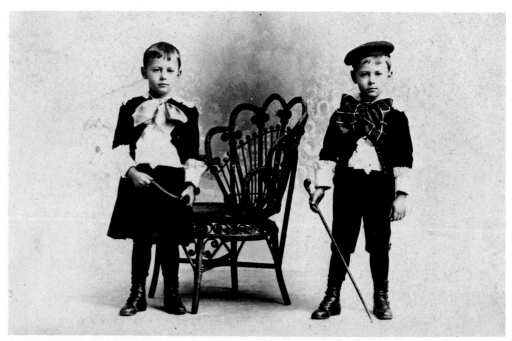

48

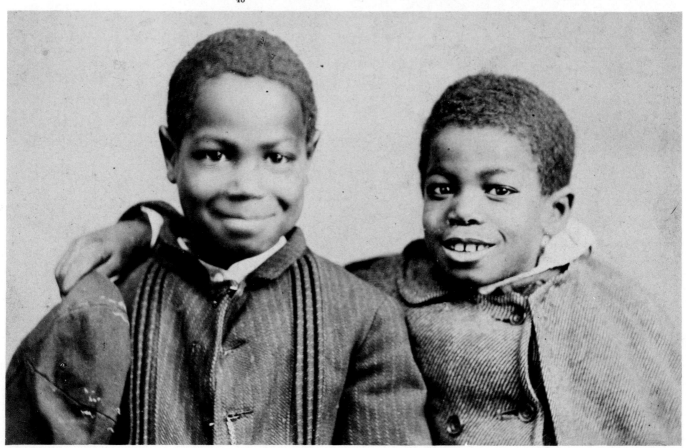

49

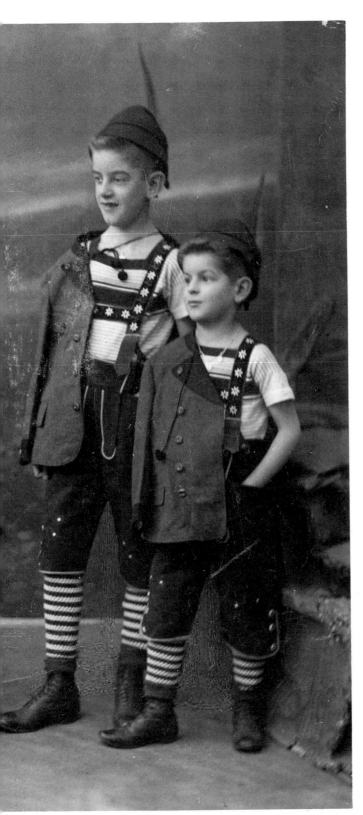

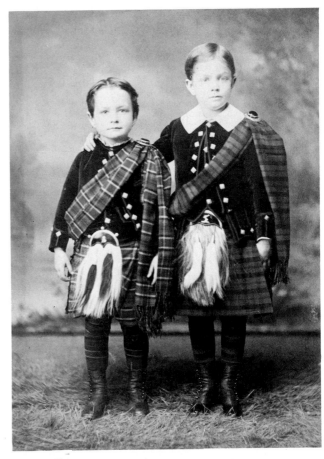

50

51

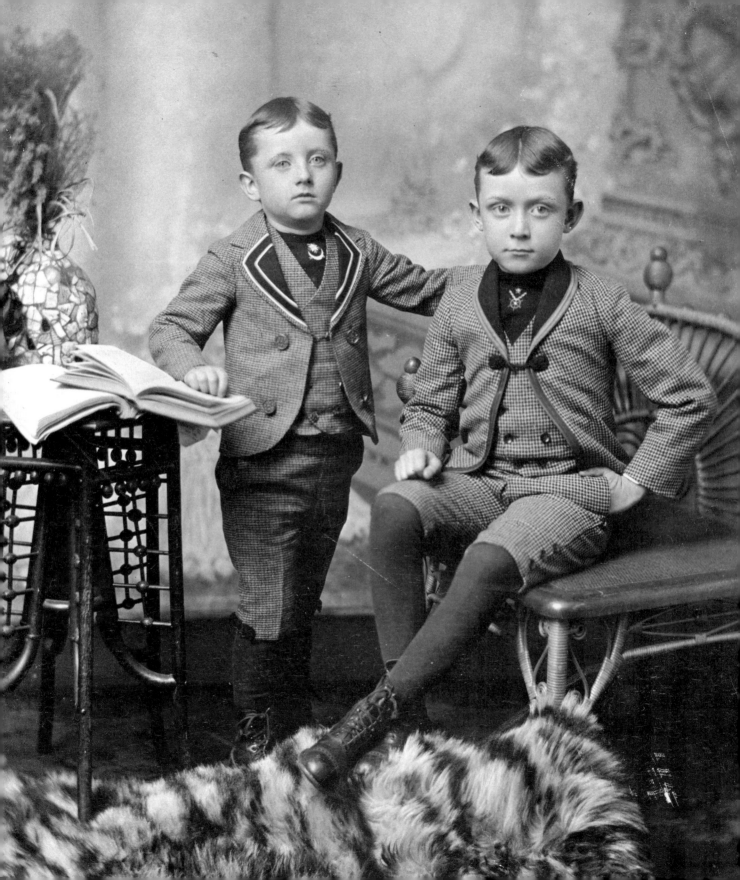

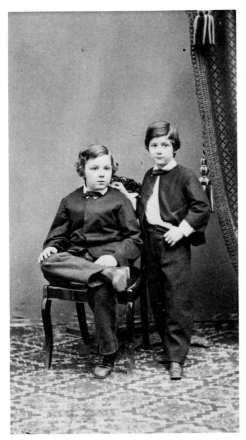

53

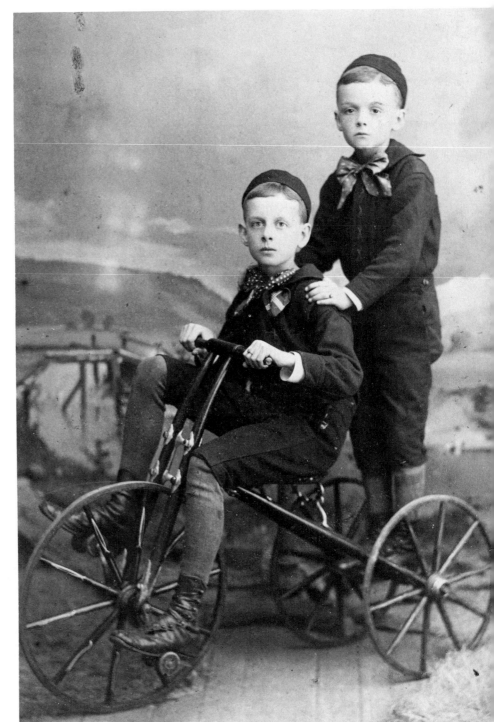

54

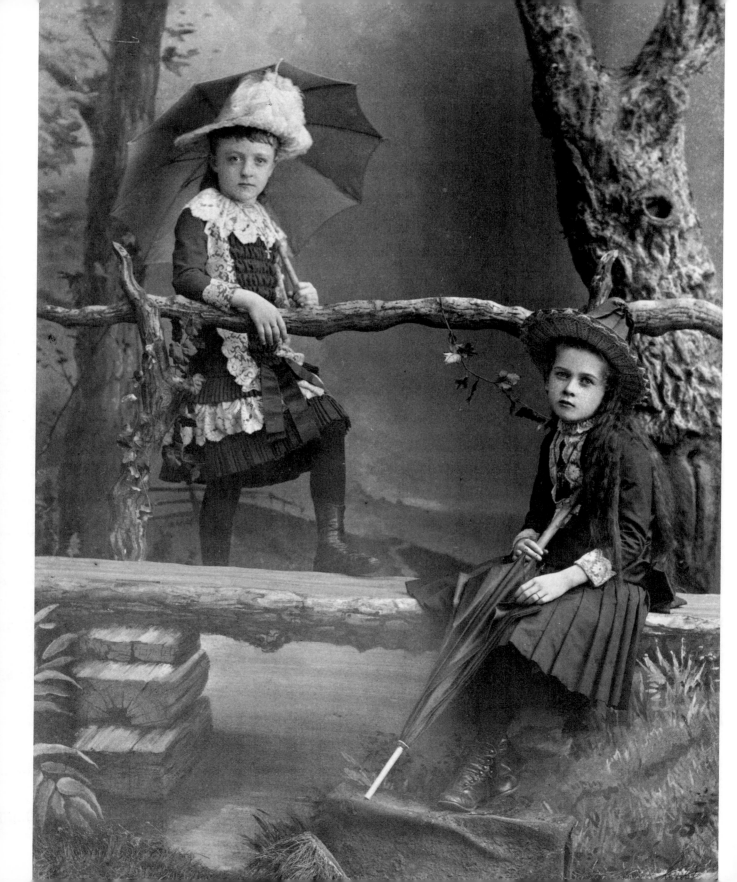

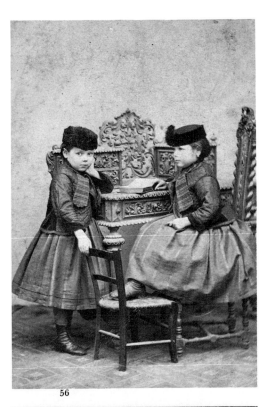

56

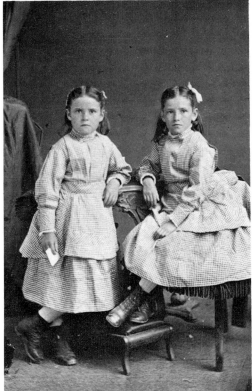

57

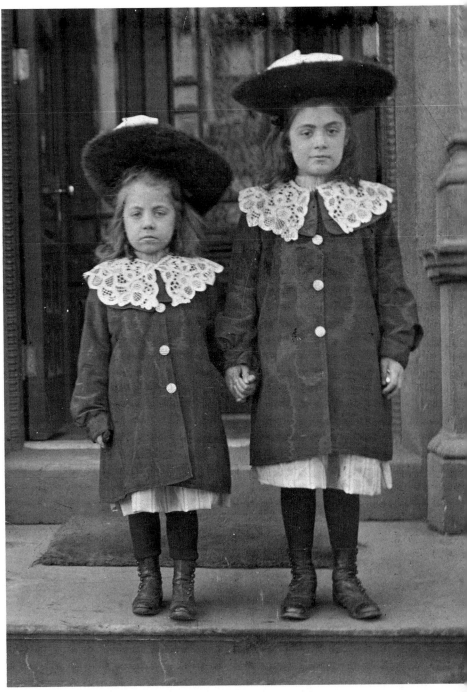

58

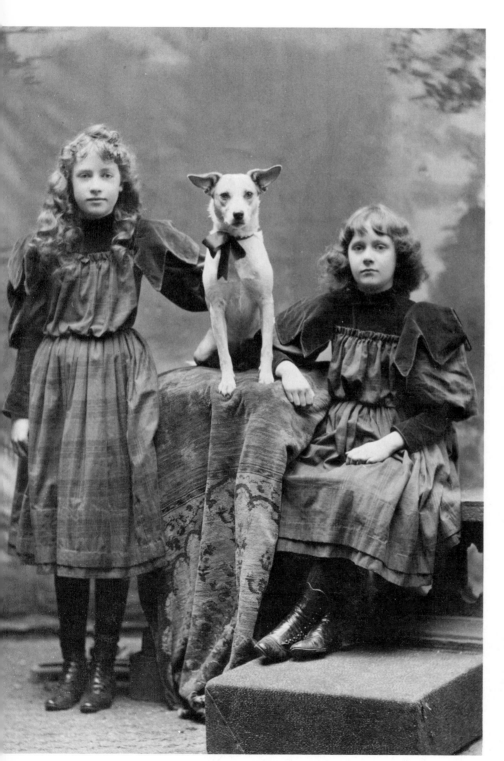

59

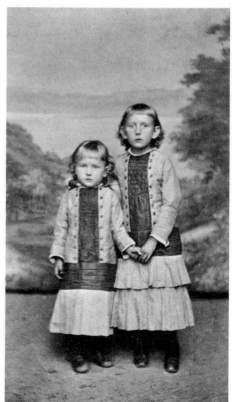

60

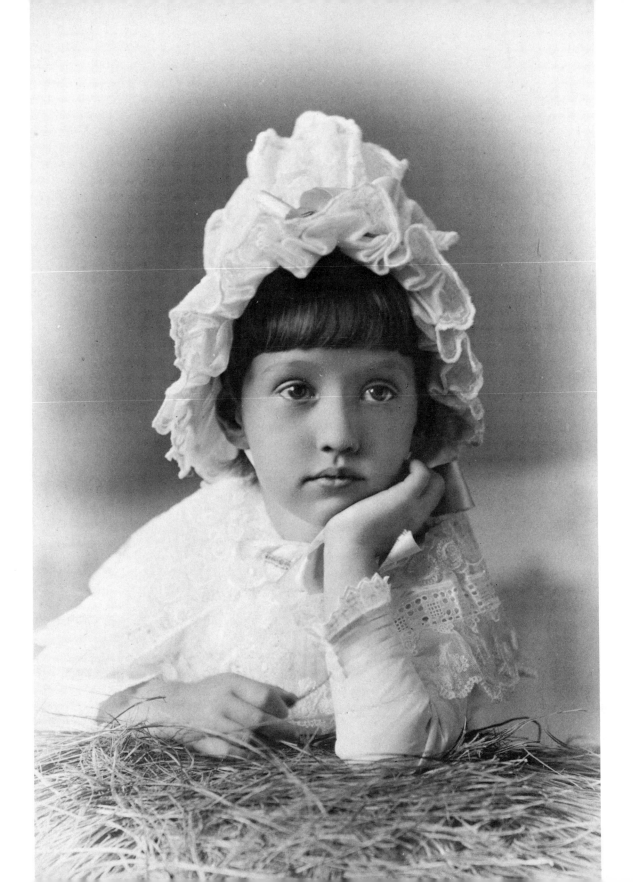

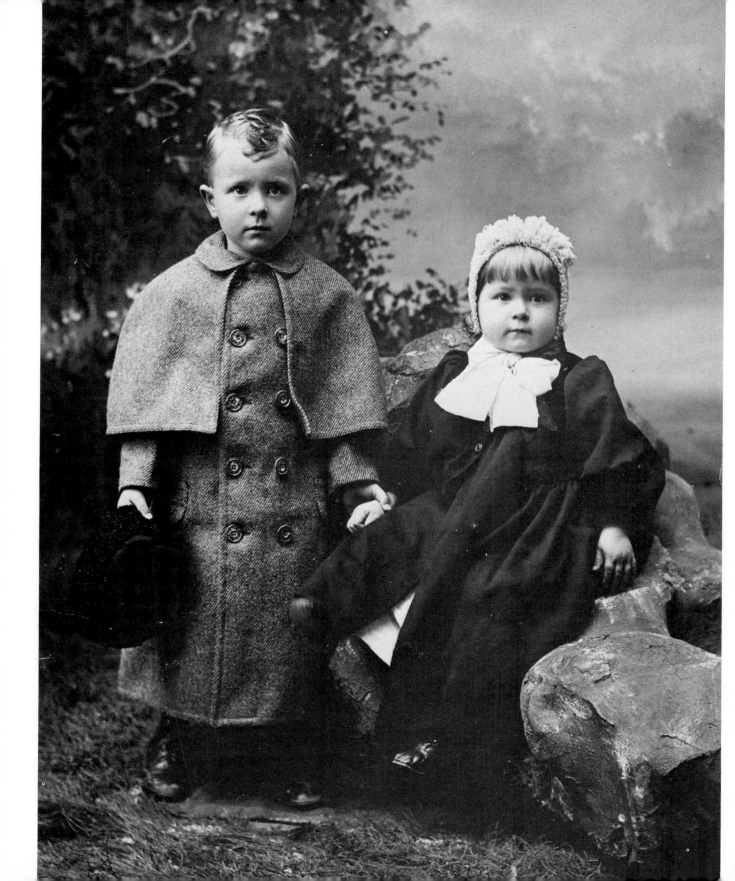

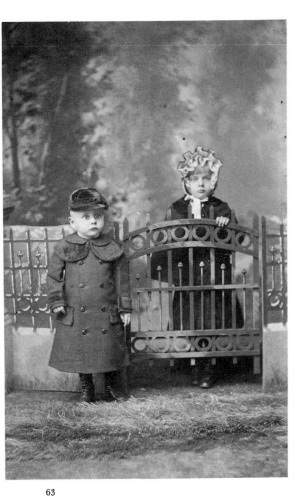

63

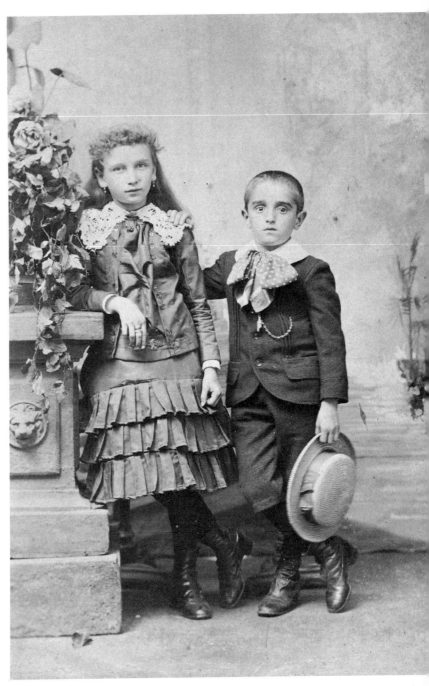

64

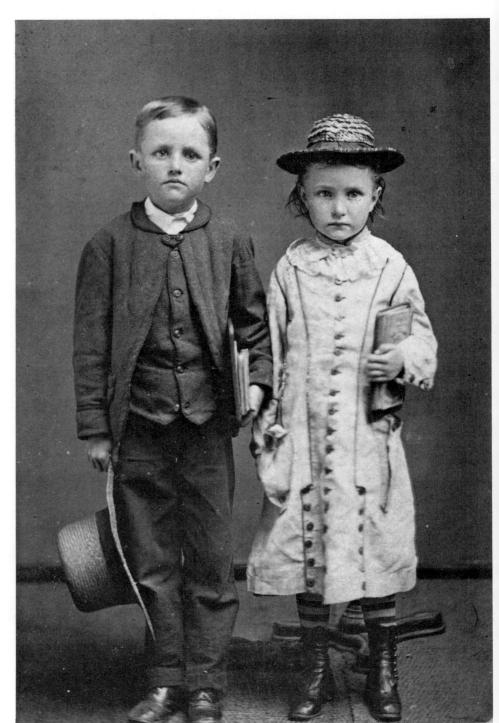

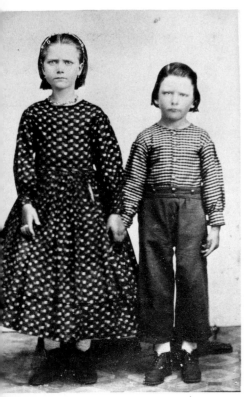

65

66

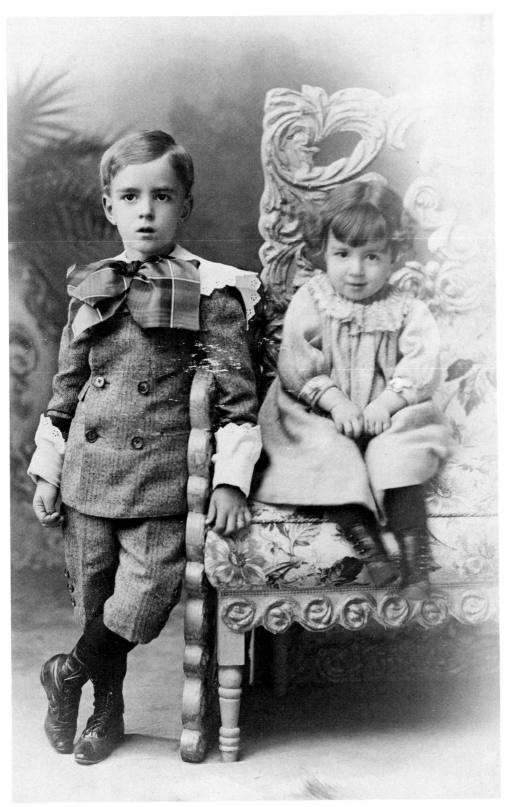

67

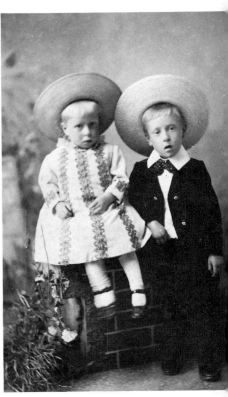

68

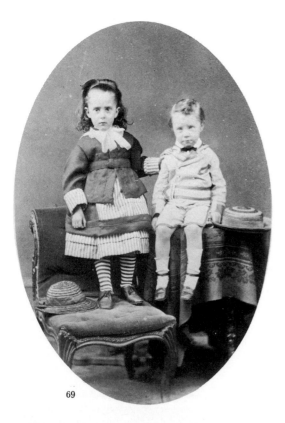

69

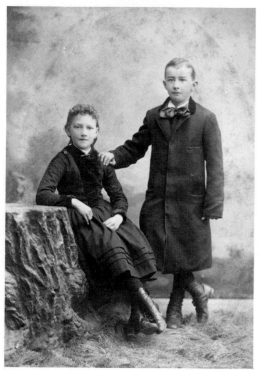

70

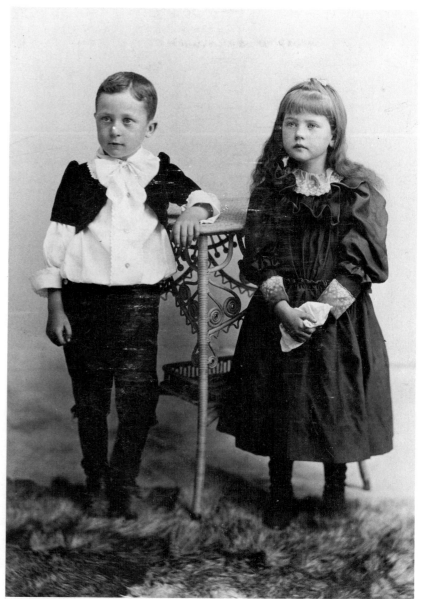

71

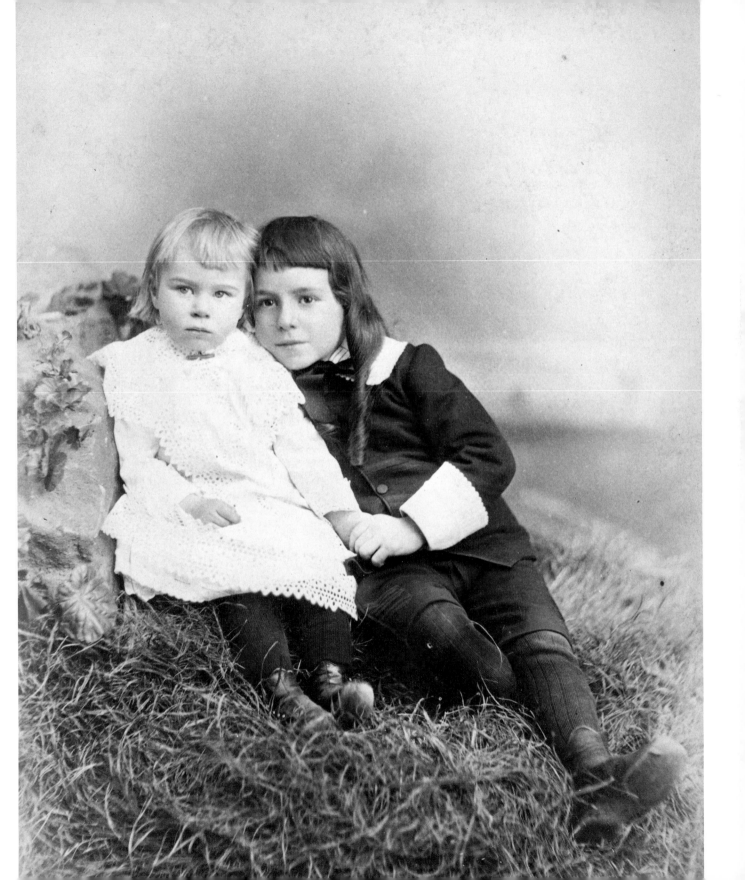

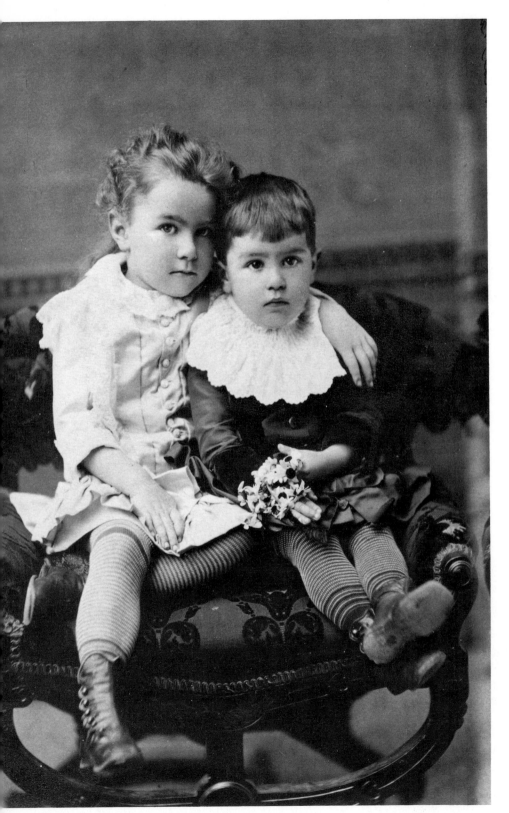

73

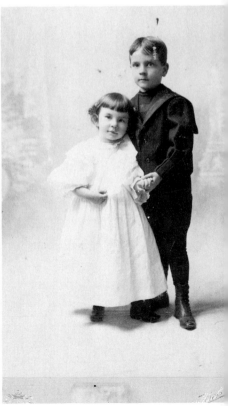

74

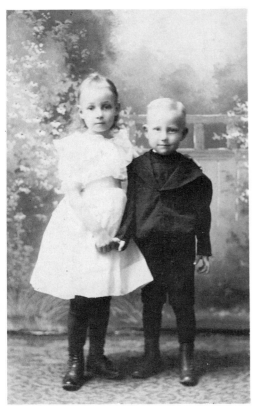

75

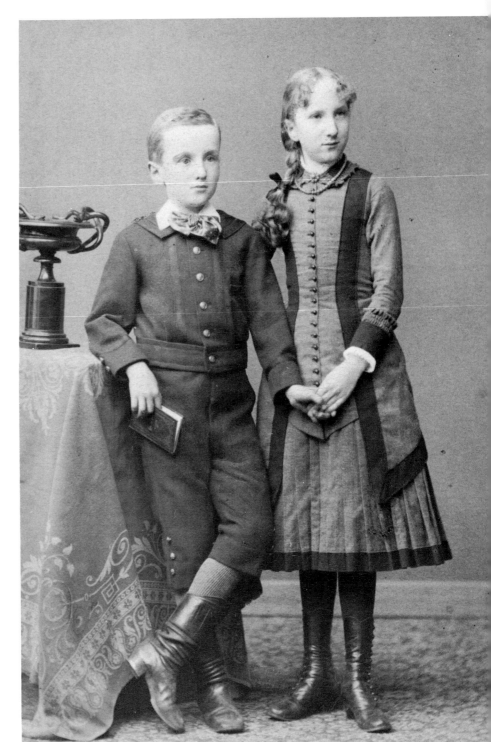

76

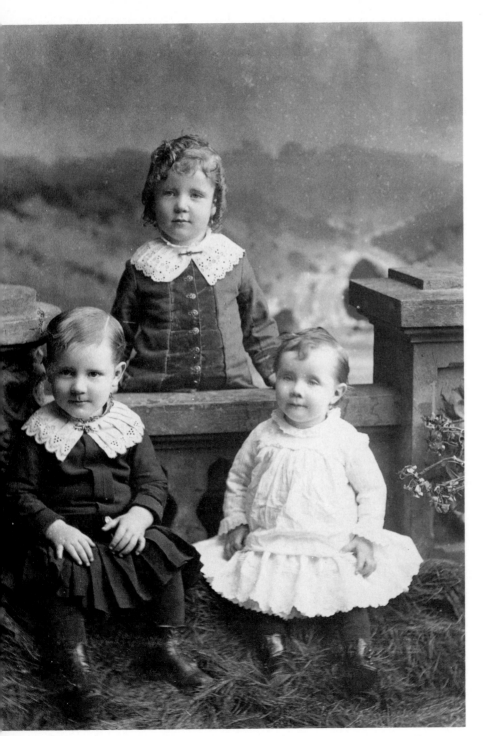

77

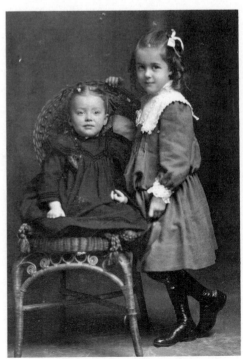

78

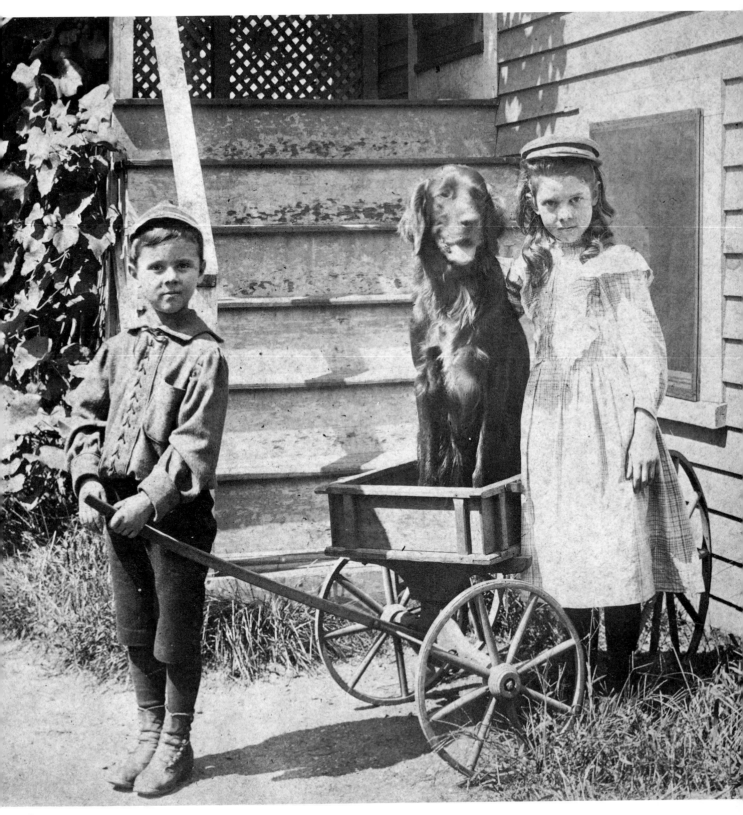

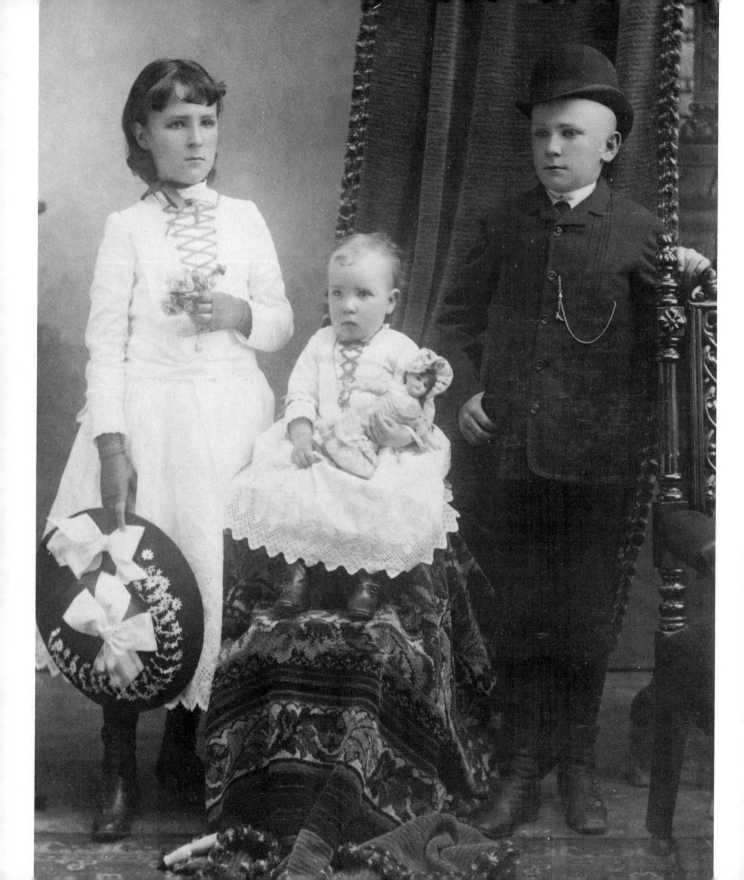

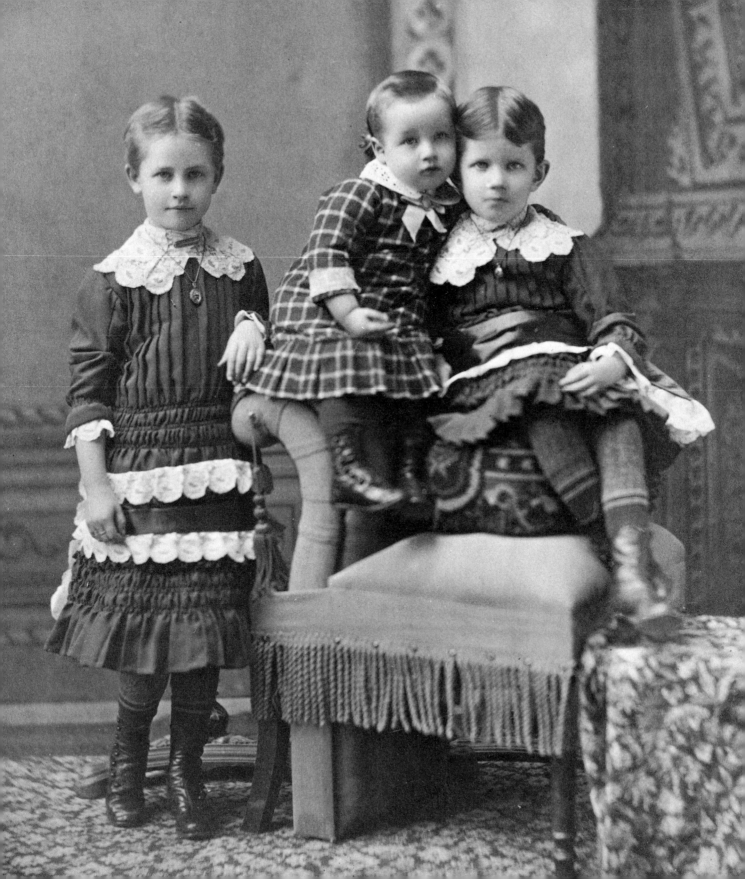

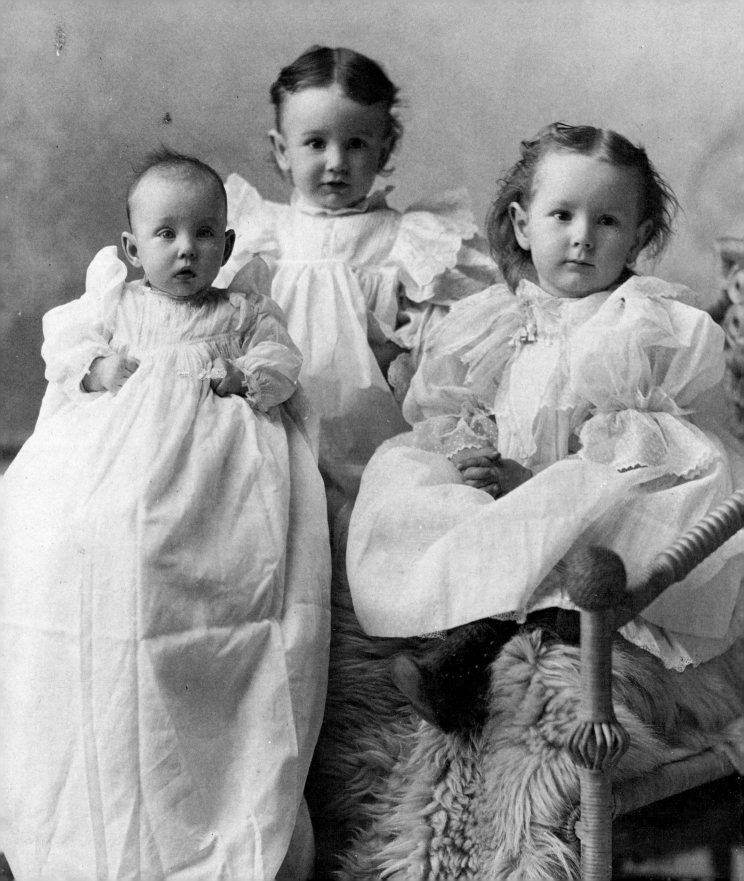

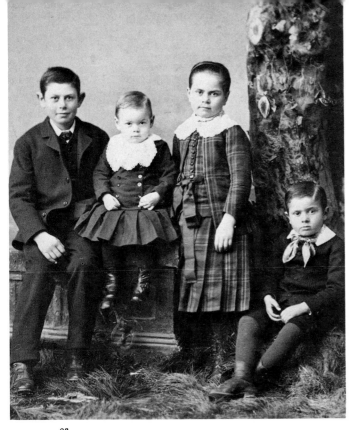

83

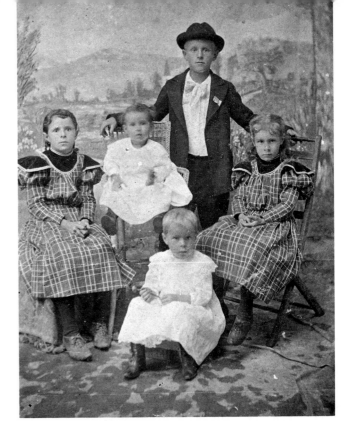

84

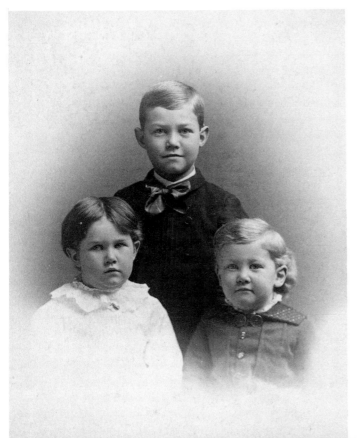

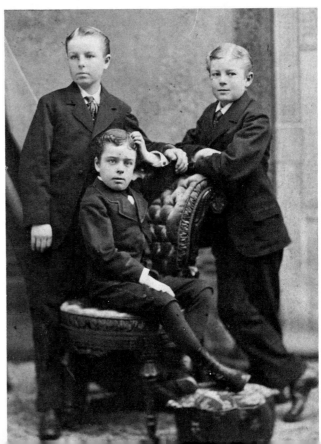

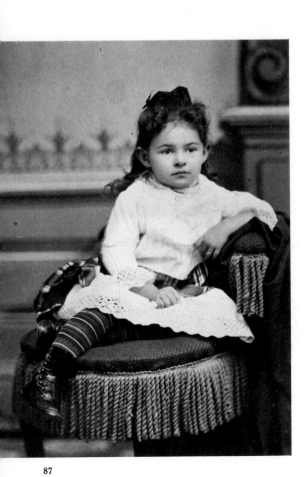

87

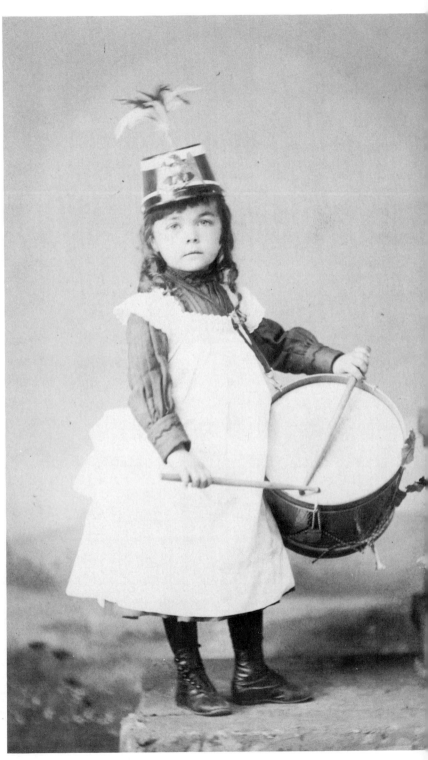

88

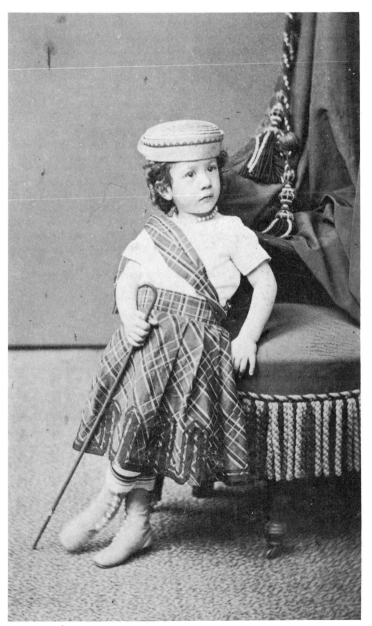

89

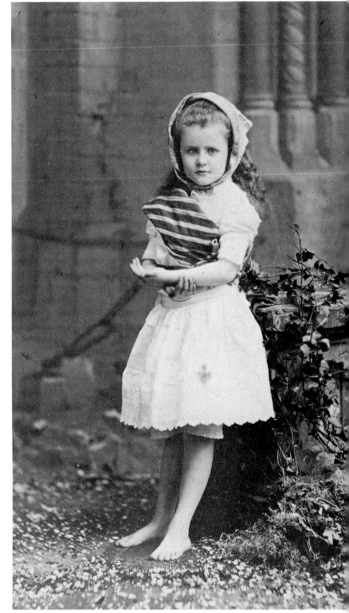

90

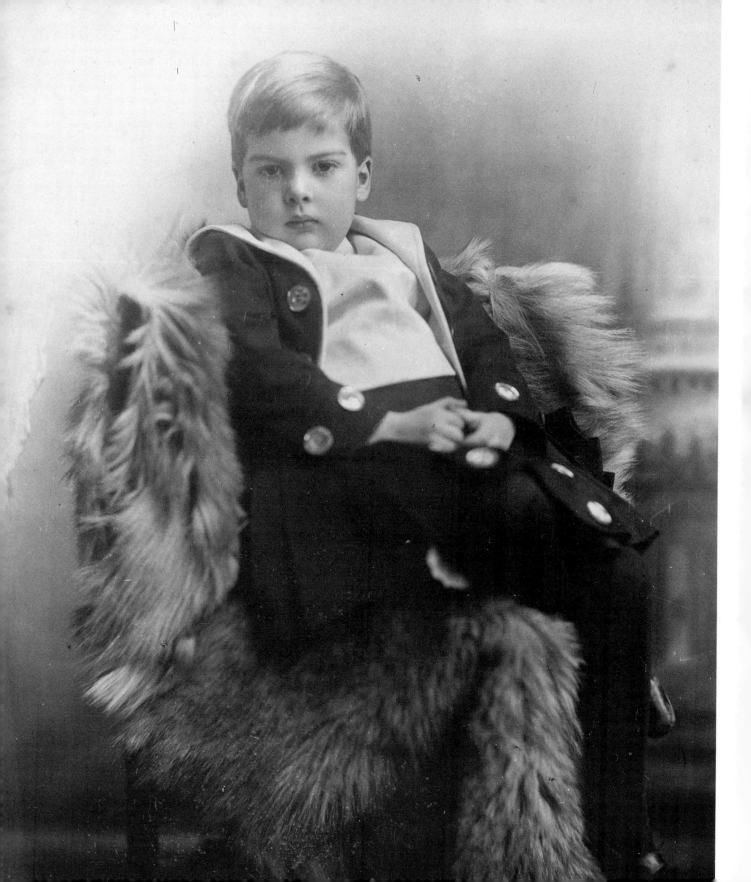

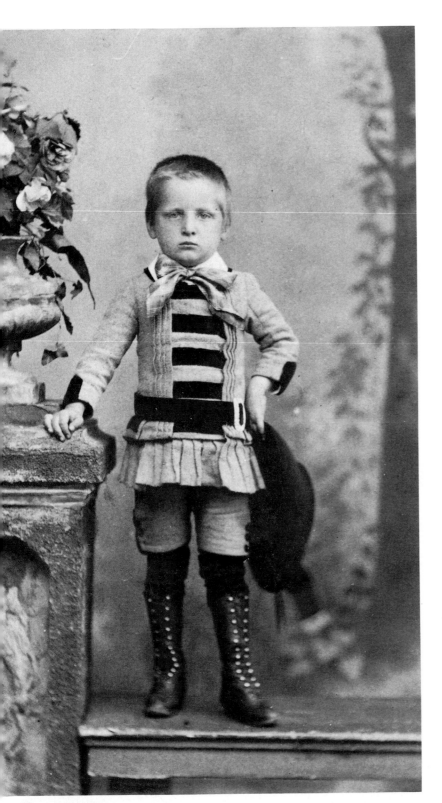

92

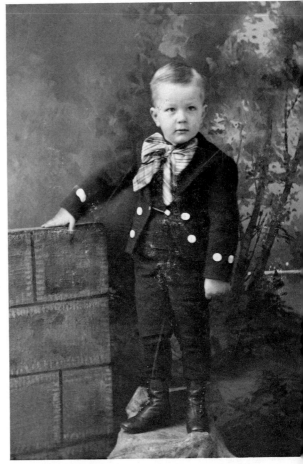

93

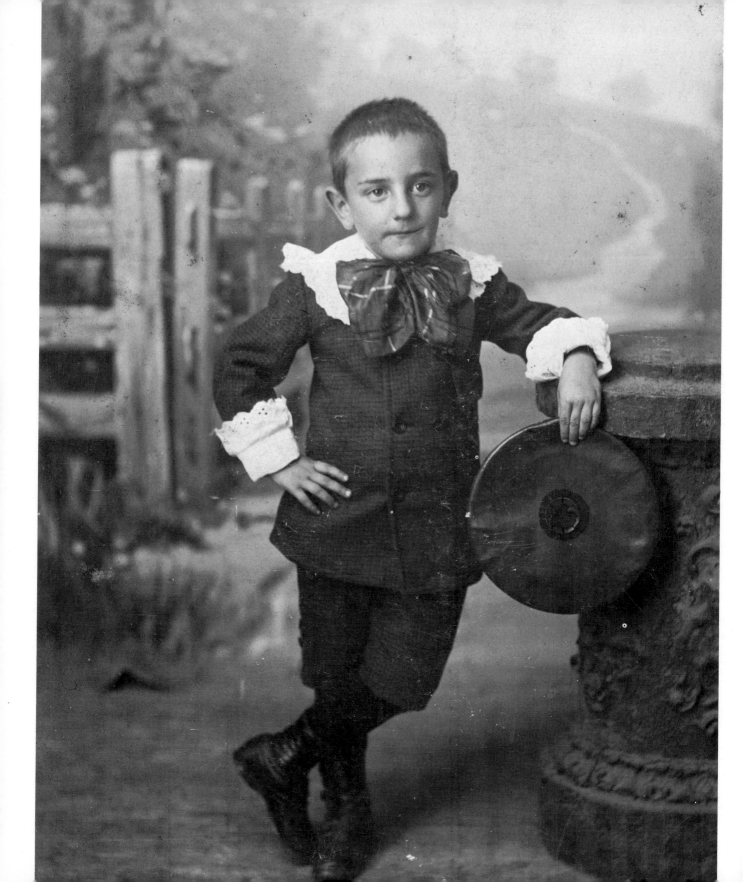

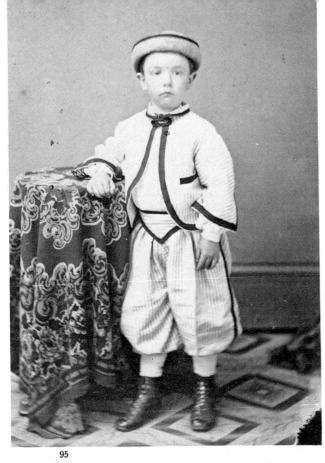

95

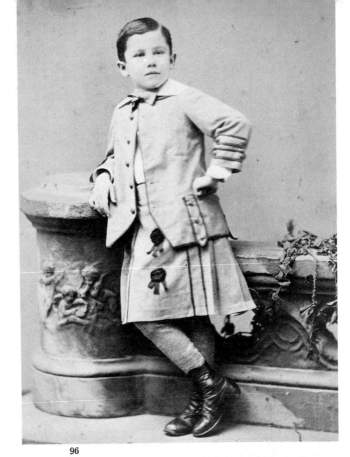

96

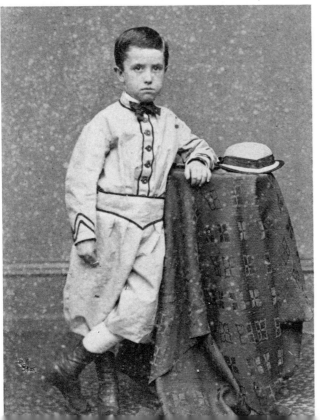

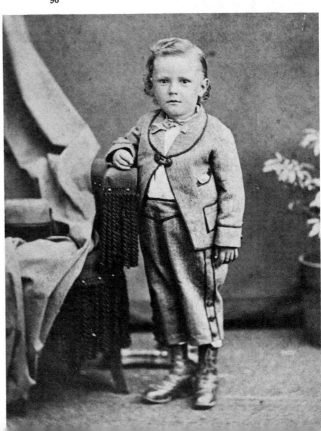

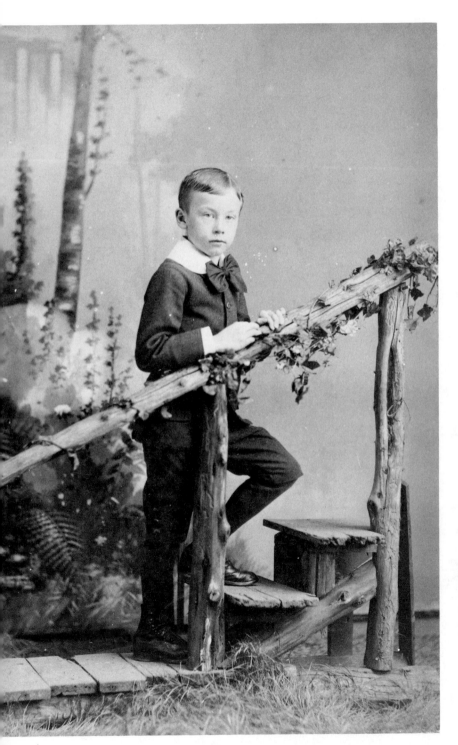

99

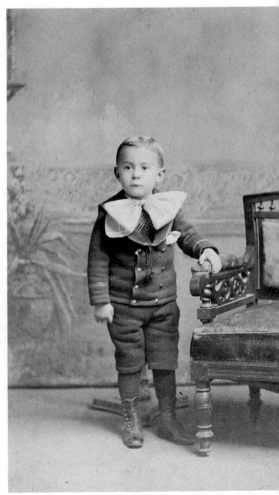

100

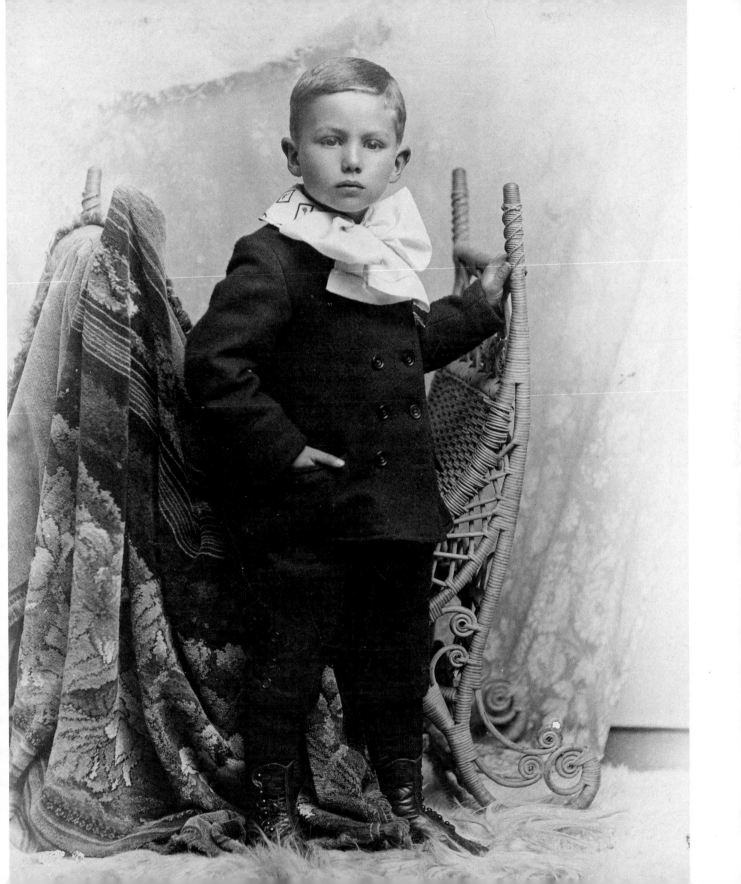

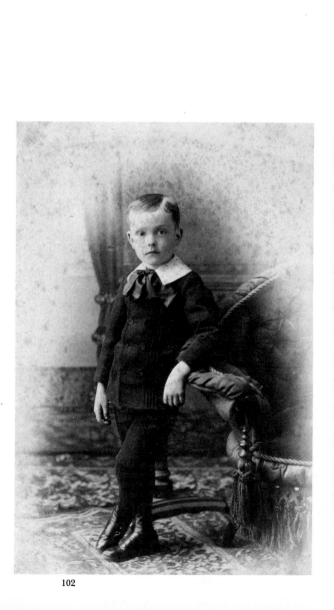

102

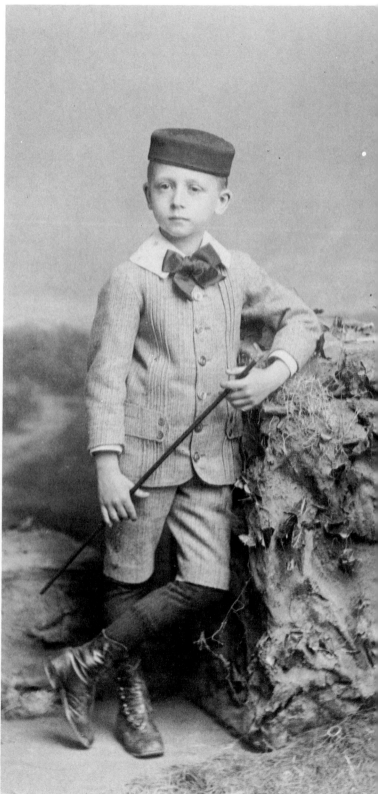

103

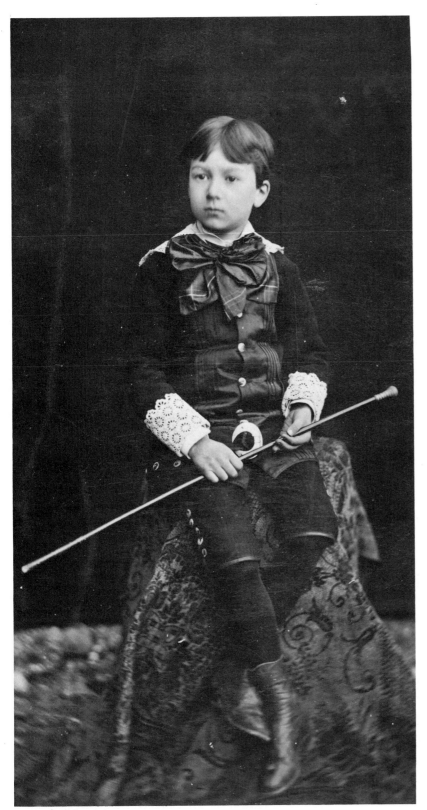

104

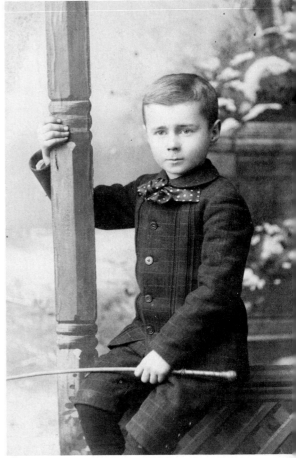

105

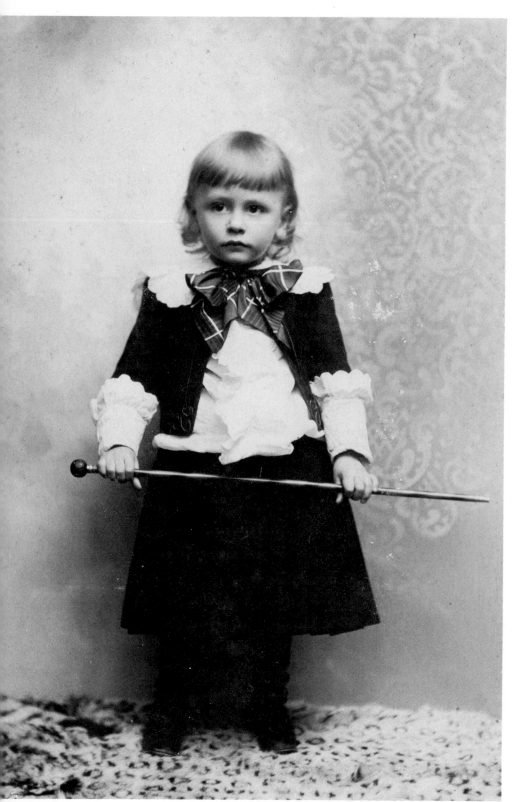

106

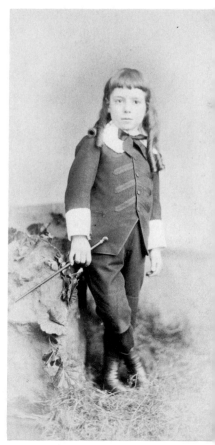

107

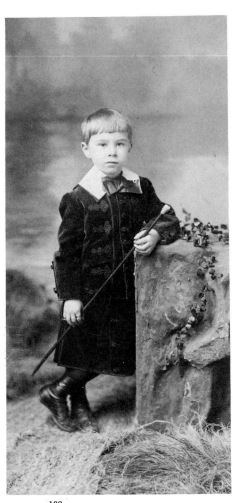

108

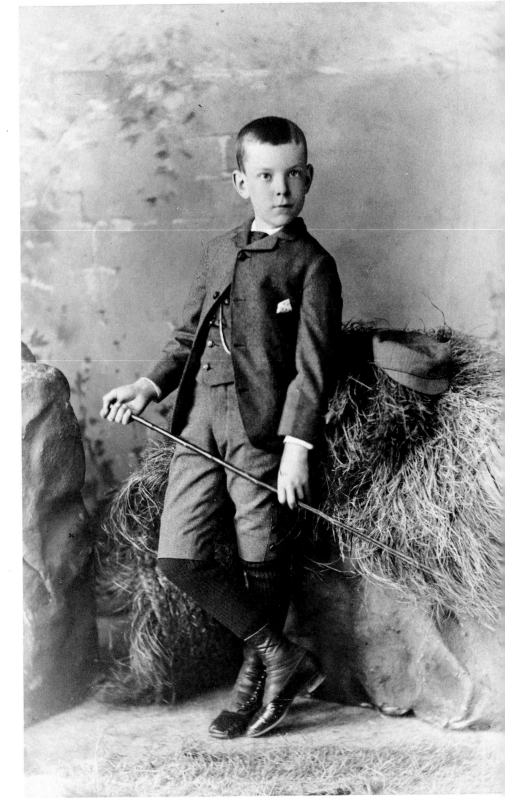

109

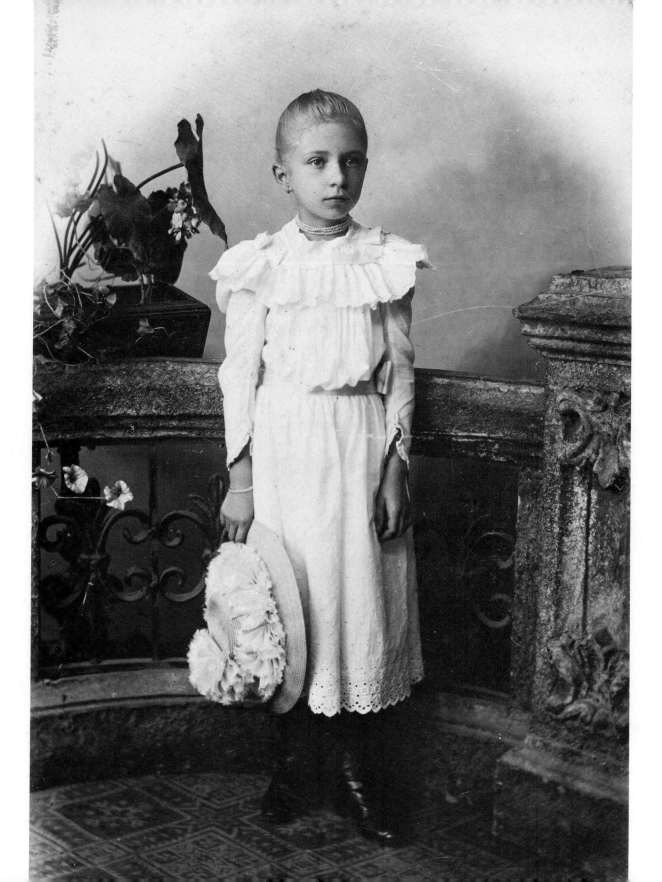

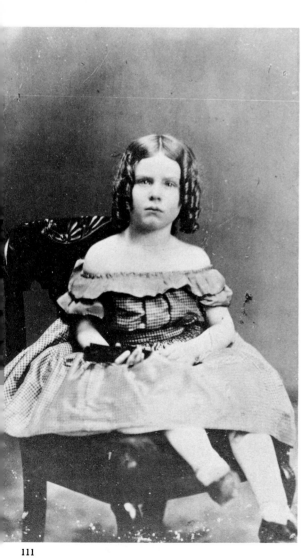

111

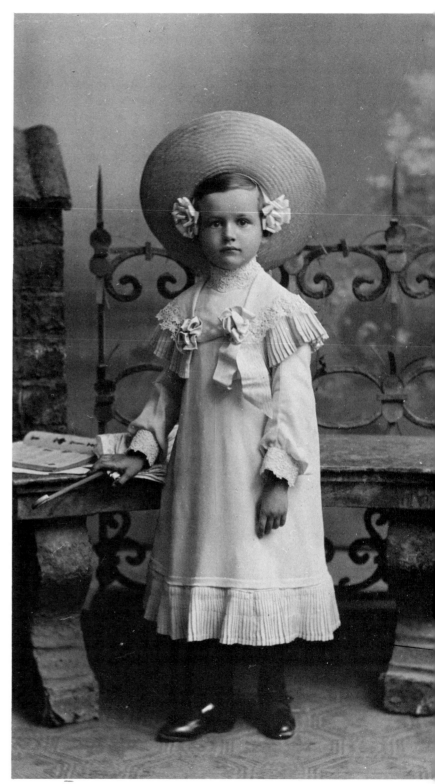

112

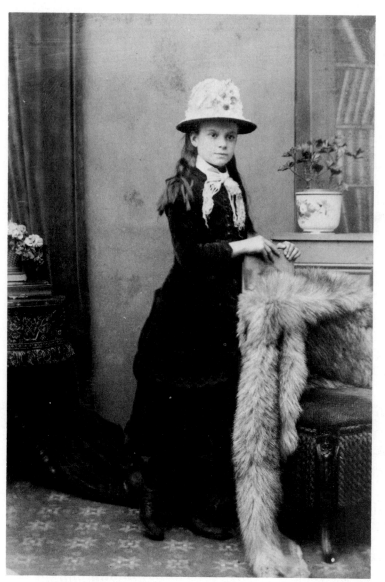

113

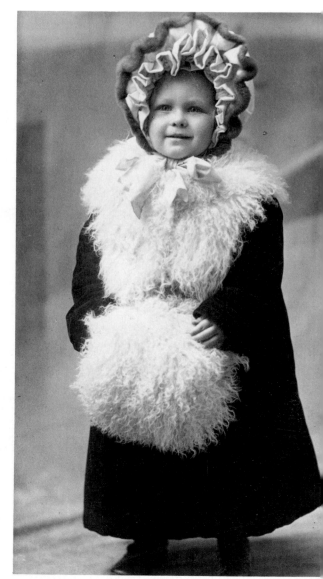

114

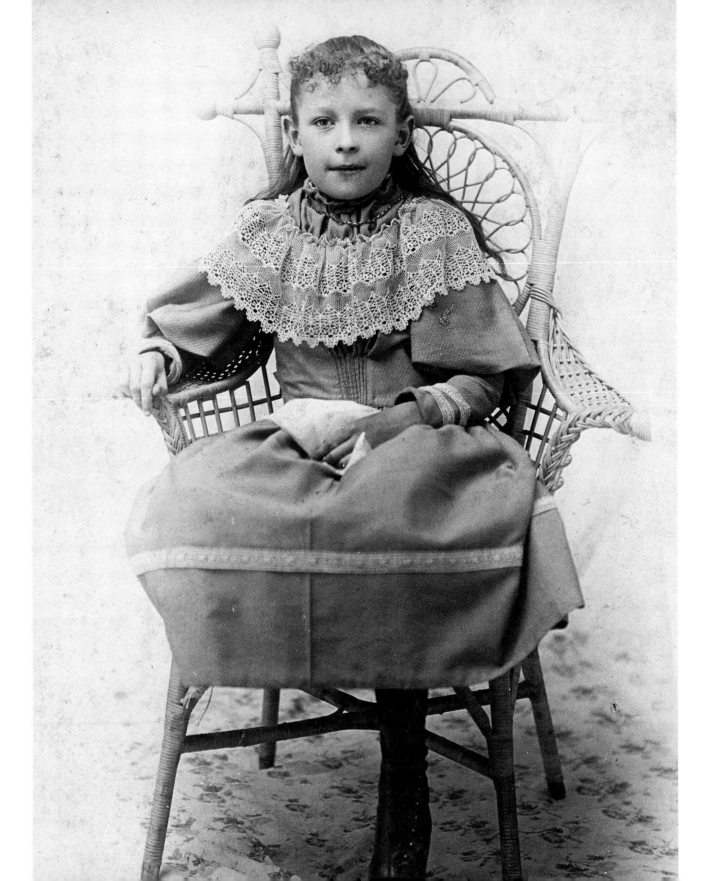

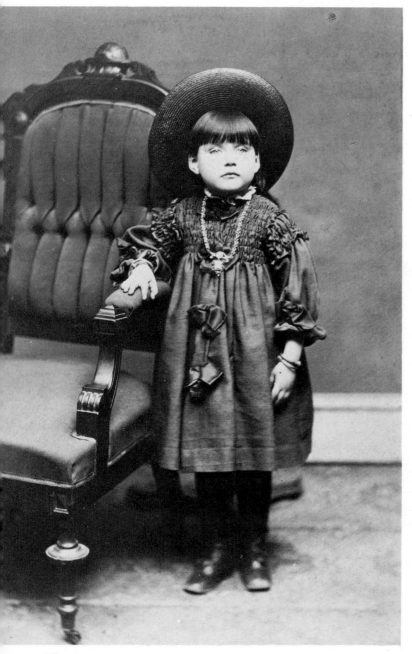

116

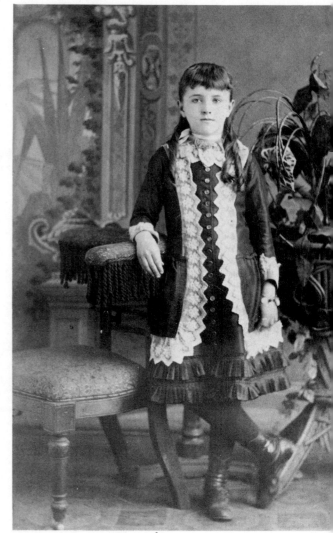

117

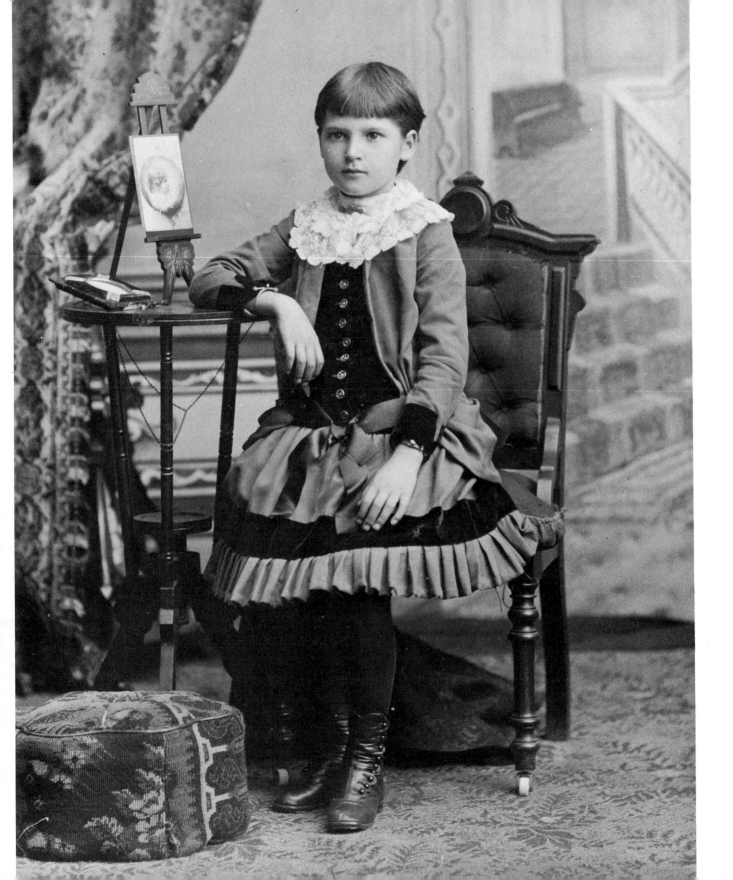

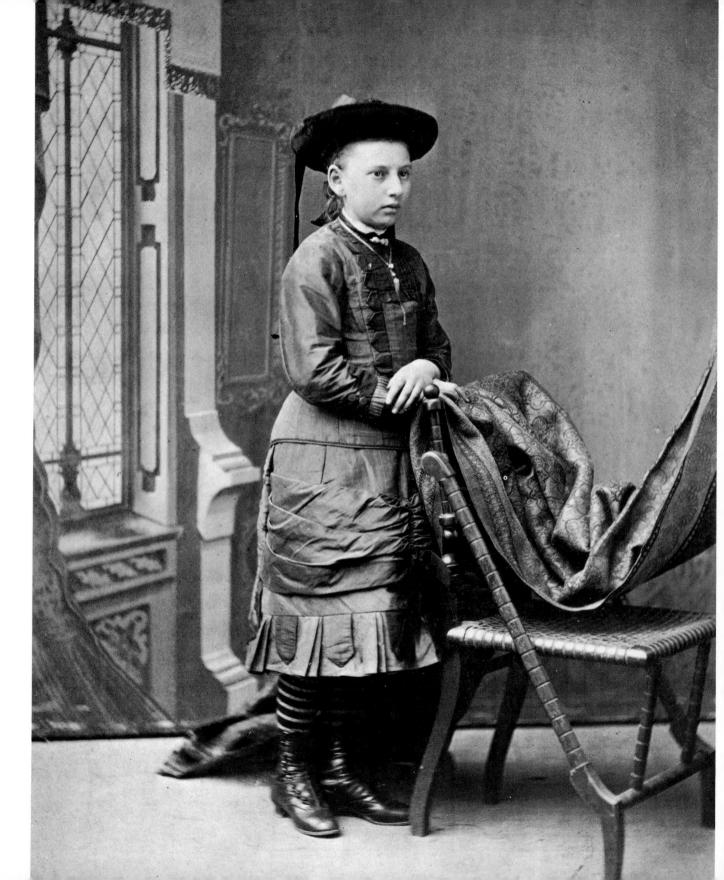

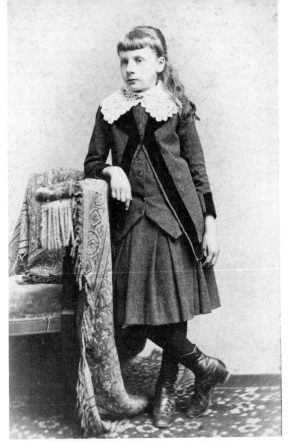

120

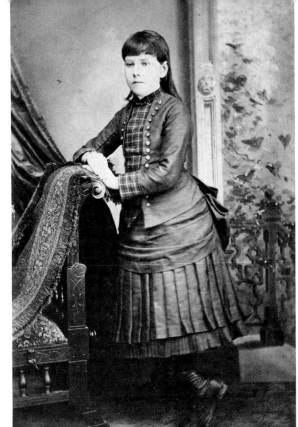

121

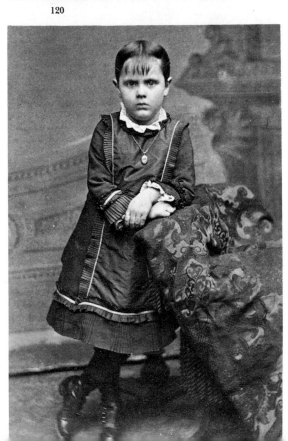

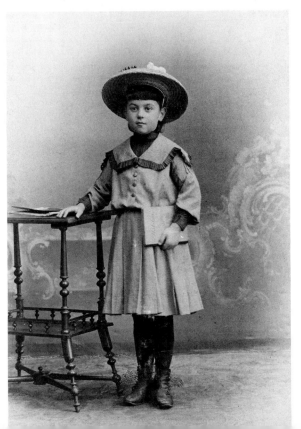

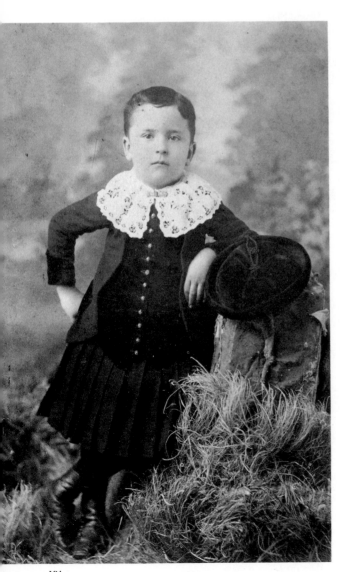

124

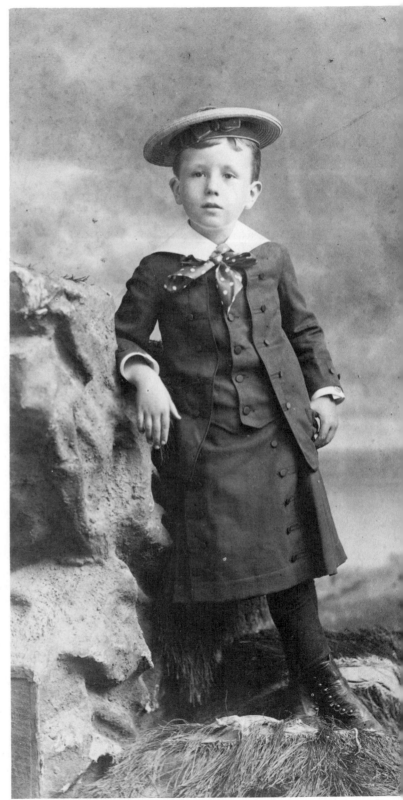

125

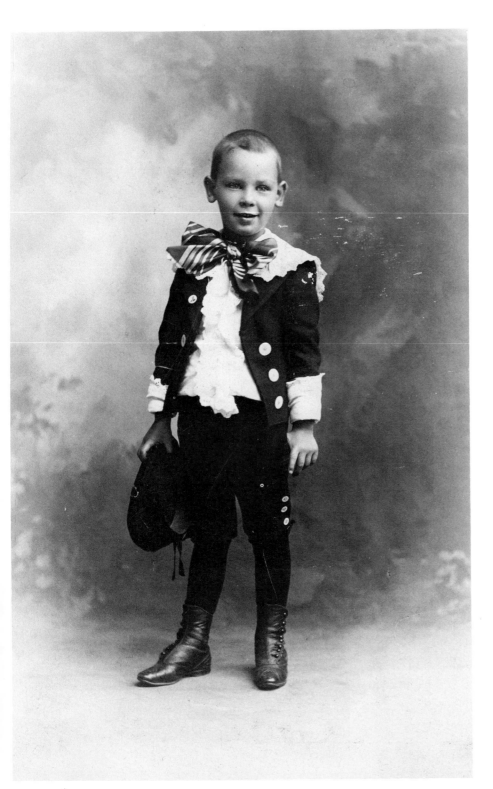

126

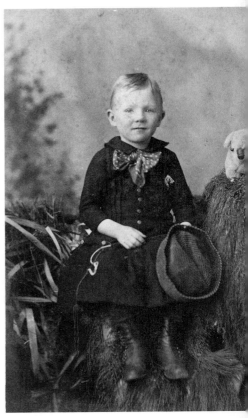

127

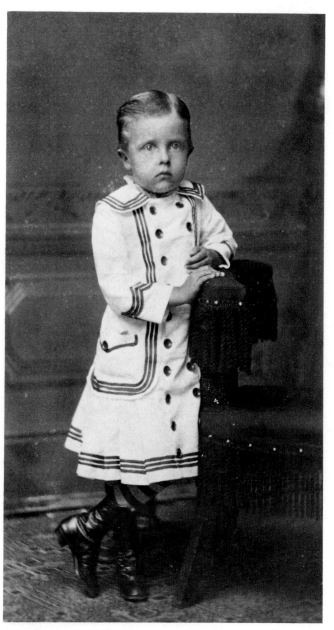

128

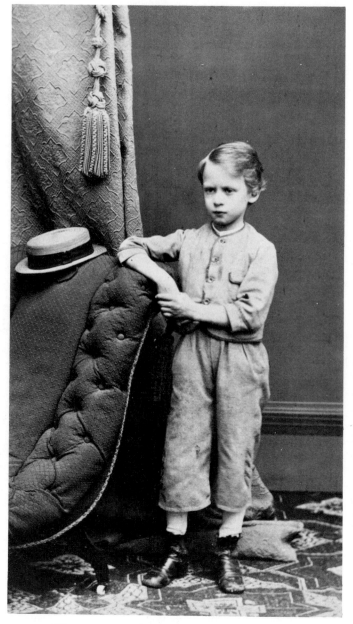

129

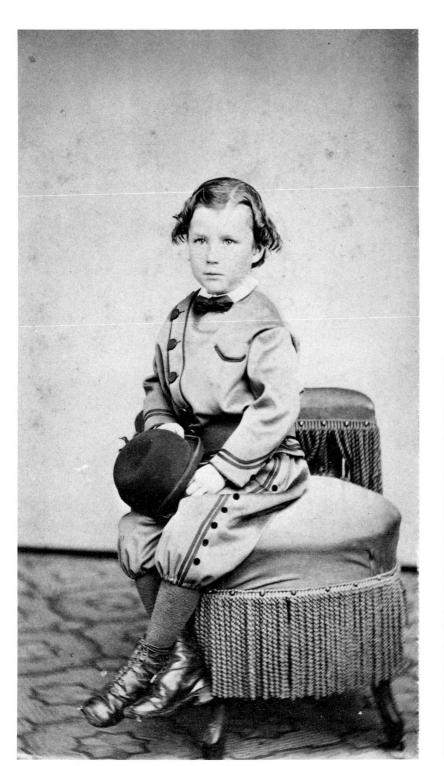

130

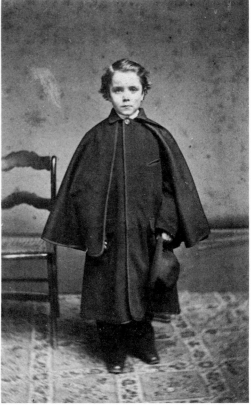

131

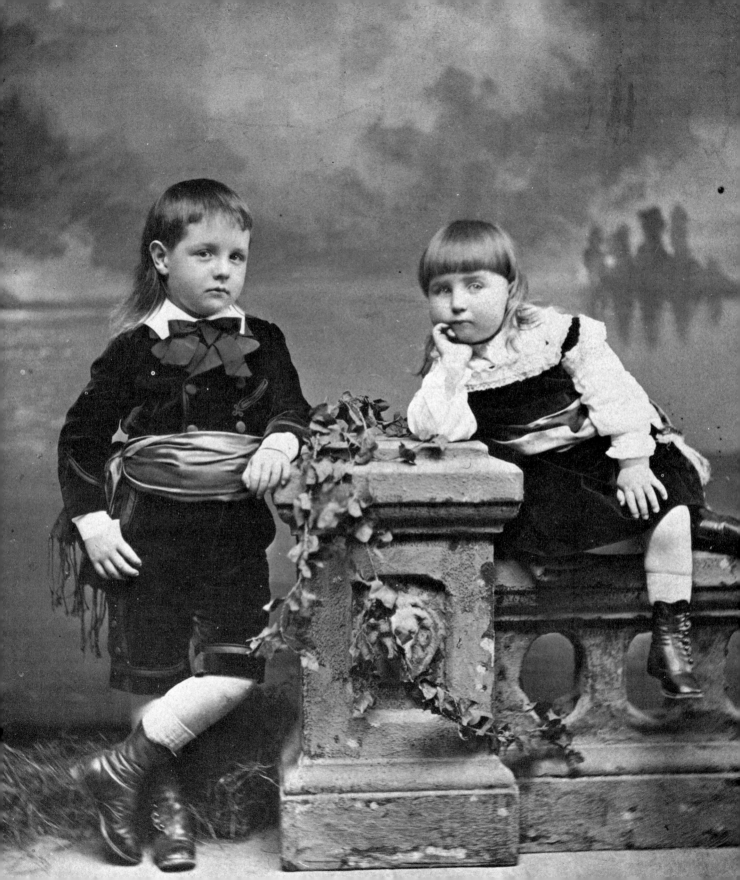

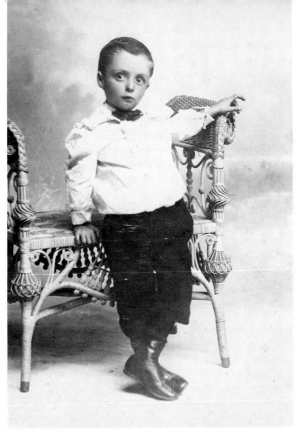

133

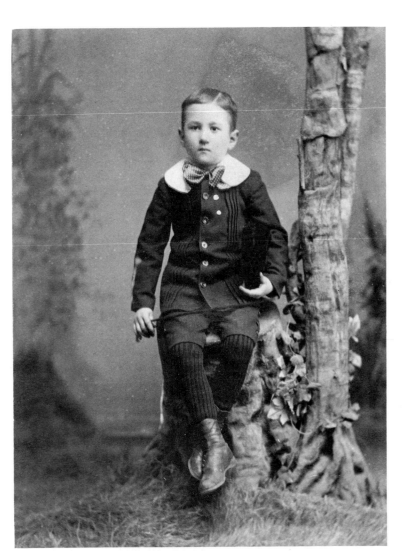

135

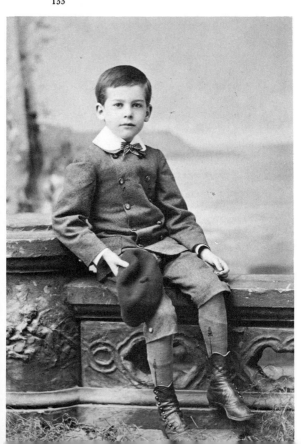

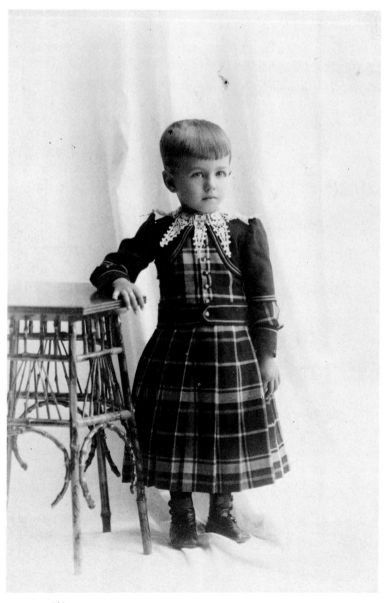

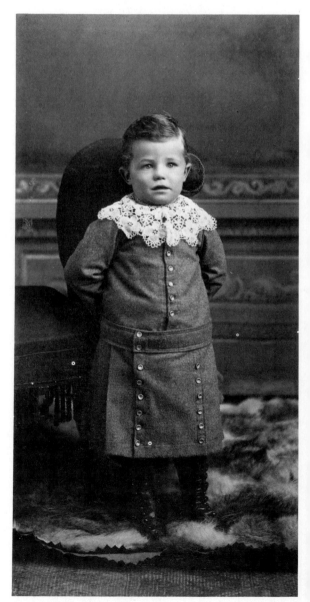

136 137

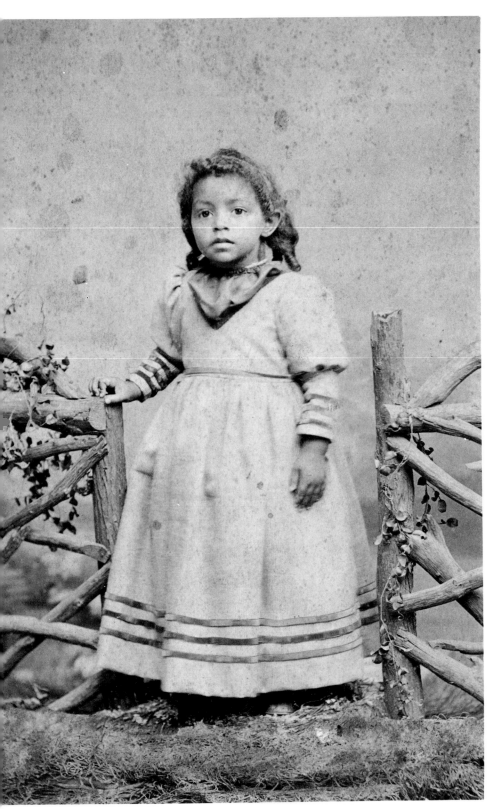

138

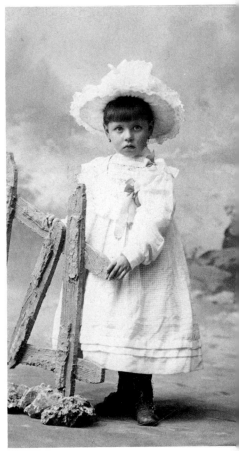

139

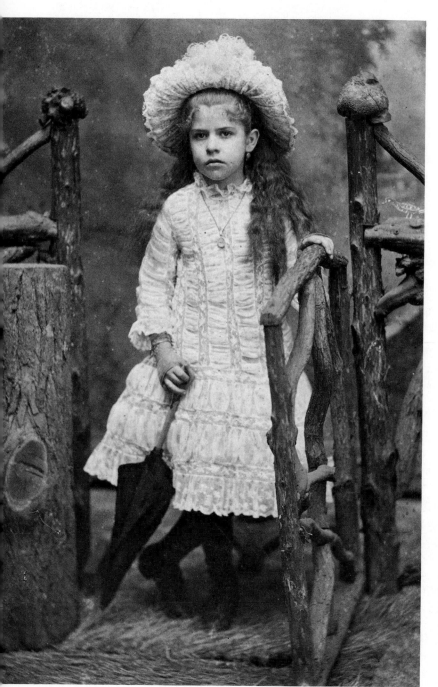

140

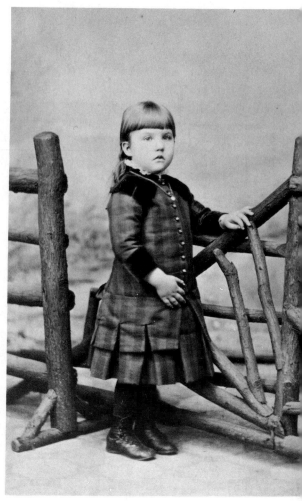

141

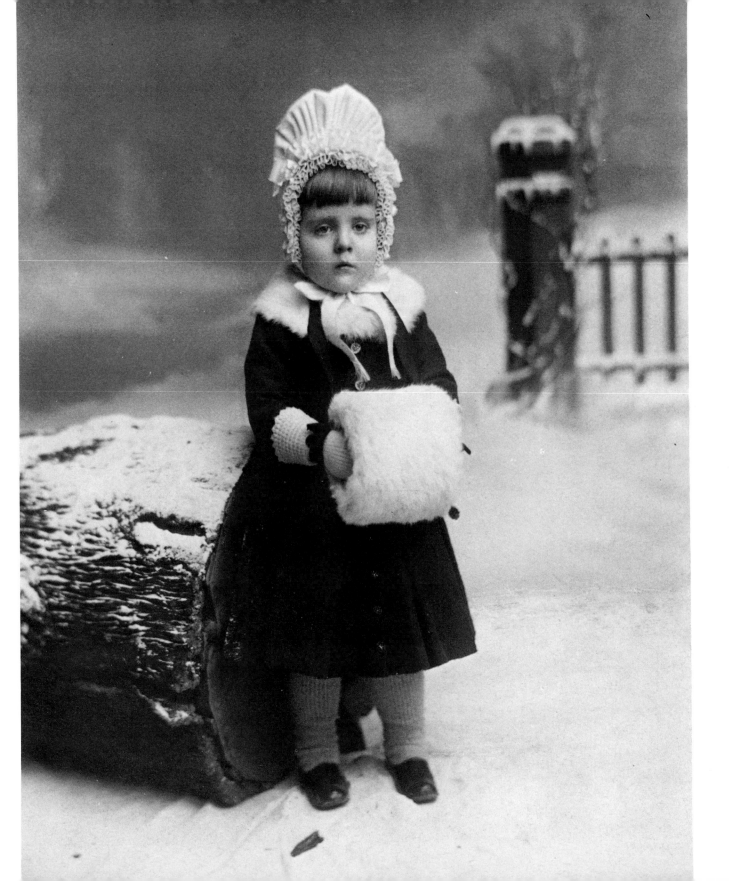

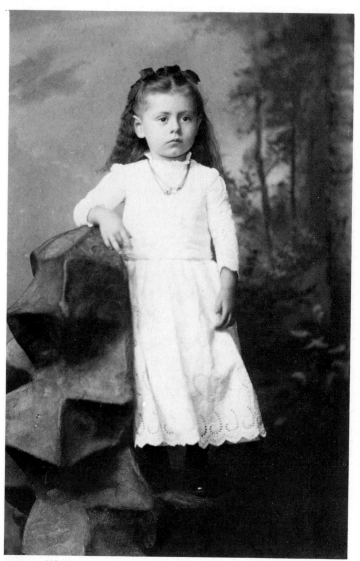

143

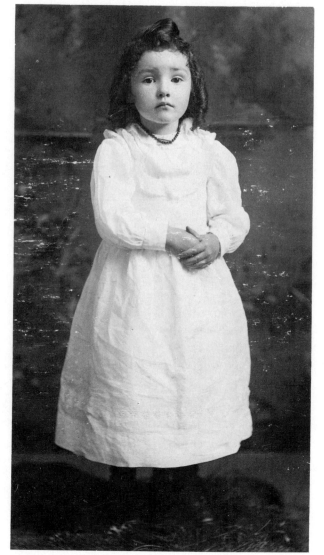

144

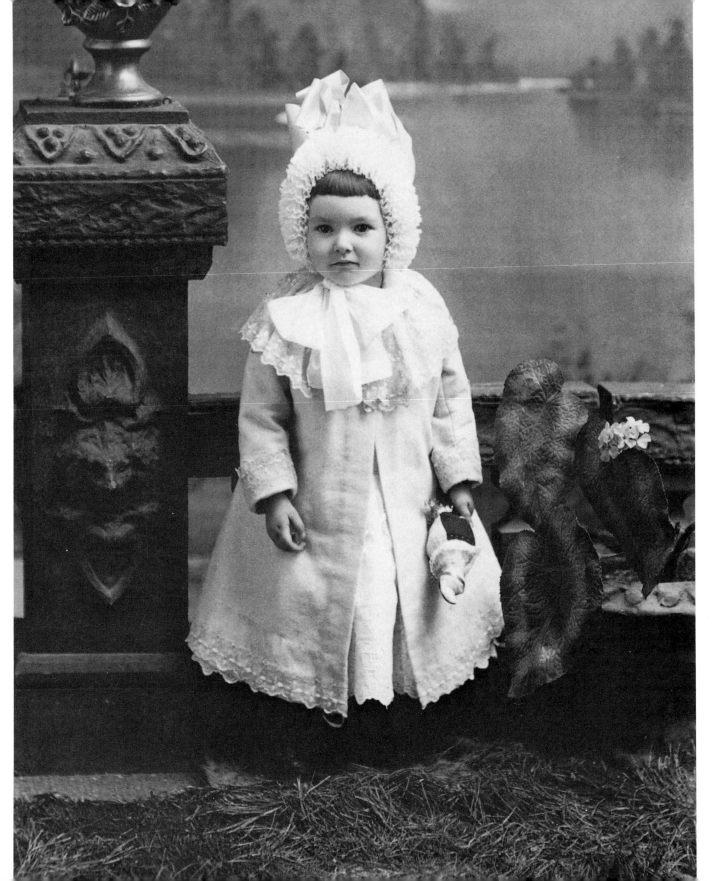

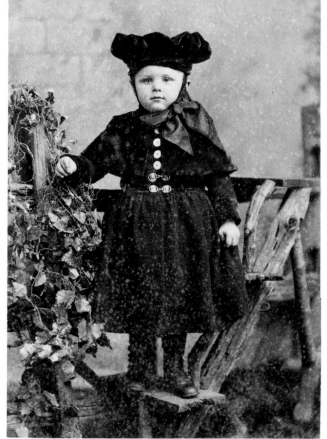

146

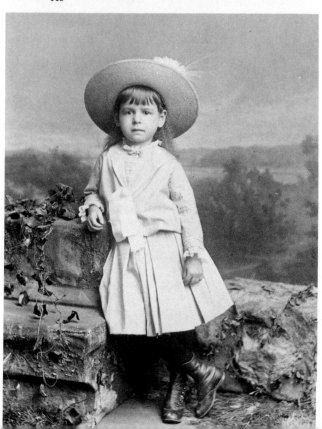

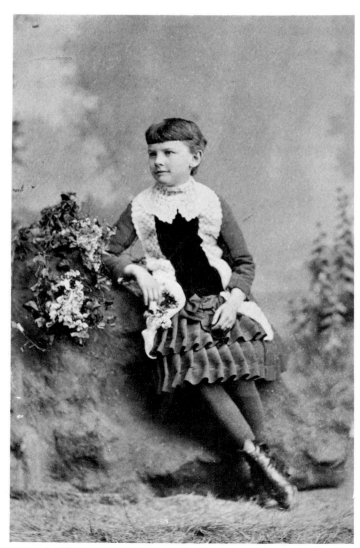

148

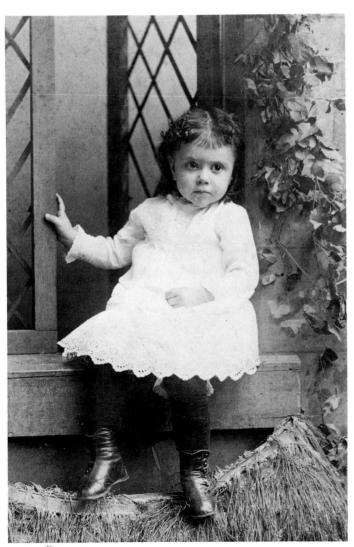

149

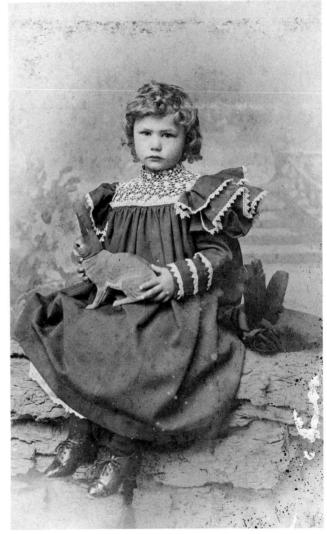

150

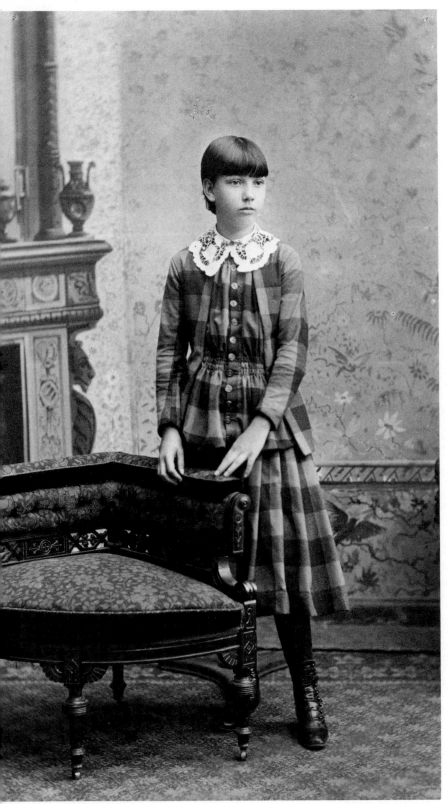

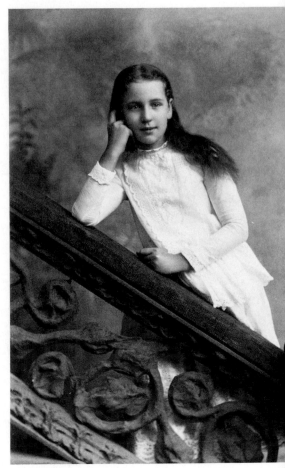

151

152

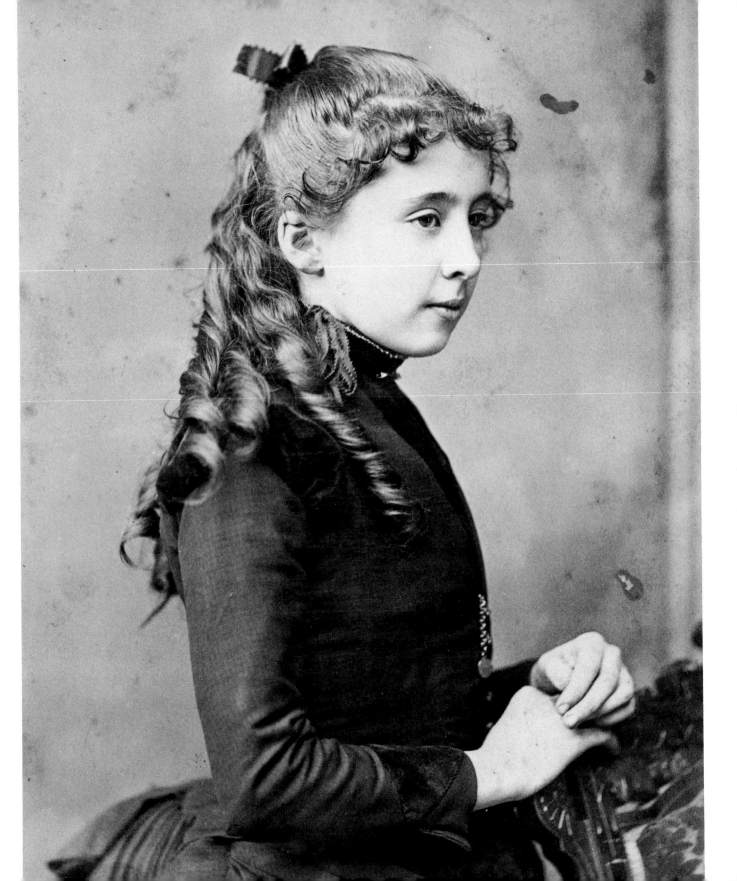

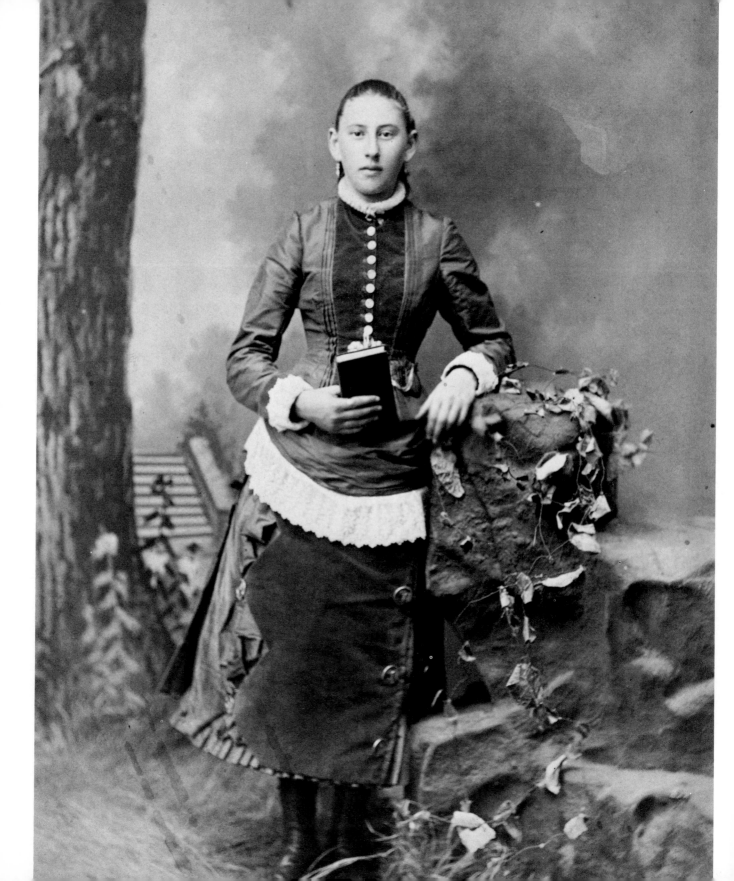

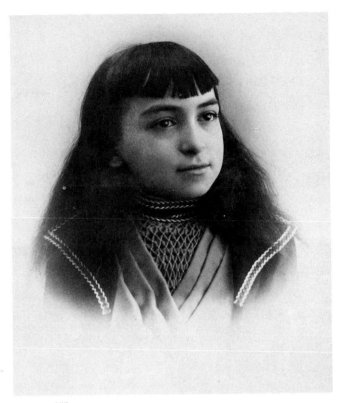

155

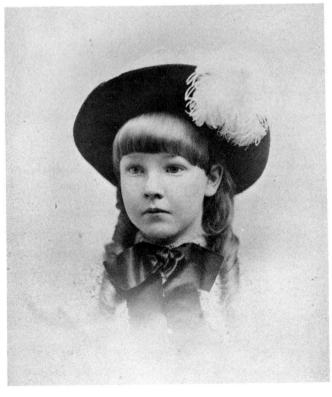

156

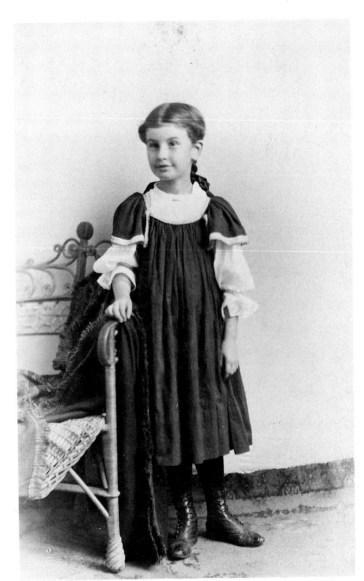

157

158

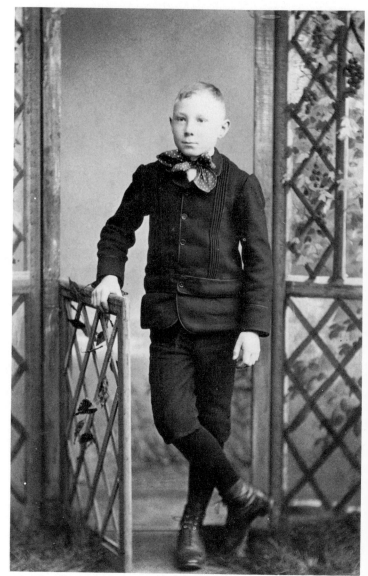

159

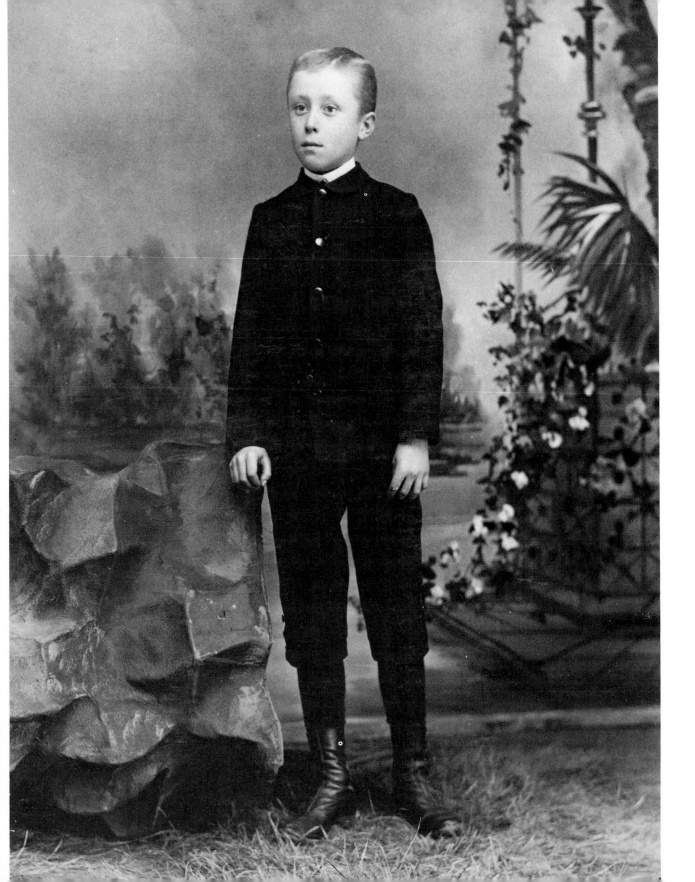

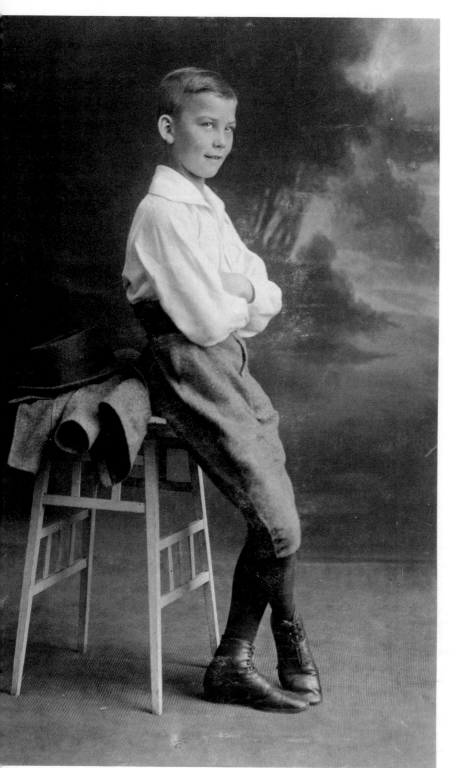

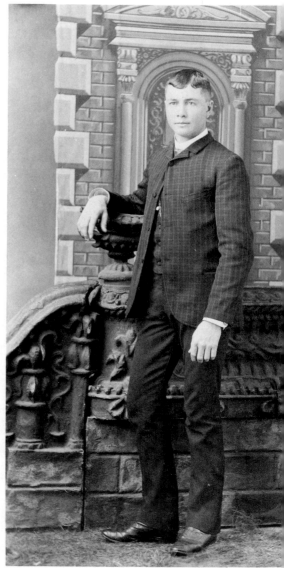

161

162

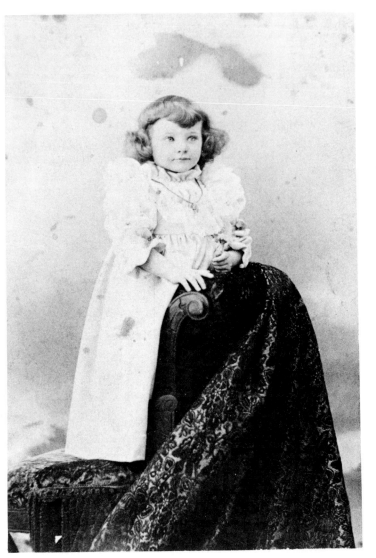

163

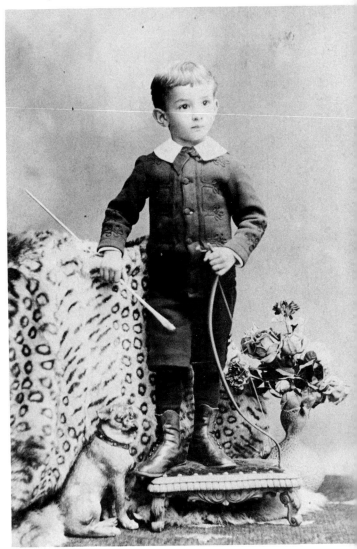

164